Let's Walk the French Quarter

A VISUAL TOUR BY KERRI MCCAFFETY

Let's Walk the French Quarter
A VISUAL TOUR BY KERRI MCCAFFETY

PELICAN PUBLISHING COMPANY

GRETNA 2014

The word "Pelican" and the depiction of a pelican are trademarks of Pelican Publishing Company, Inc., and are registered in the U.S. Patent and Trademark Office.

Library of Congress Cataloging-in-Publication Data

McCaffety, Kerri, author, photographer.
 Let's walk the French Quarter : a visual tour / by Kerri McCaffety.
 pages cm
 ISBN 978-1-4556-1931-3 (alk. paper)
 1. Vieux Carré (New Orleans, La.)--Pictorial works. 2. Vieux Carré (New Orleans, La.)--Buildings, structures, etc.--Pictorial works. 3. New Orleans (La.)--Pictorial works. 4. New Orleans--Buildings, structures, etc.--Pictorial works. 5. Historic buildings--Louisiana--New Orleans--Pictorial works. I. Title.
 F379.N56V5354 2014
 976.3'35--dc23
 2013046468

All photographs and text first appeared in the following books by Kerri McCaffety: Obituary Cocktail: The Great Saloons of New Orleans; The Majesty of the French Quarter; *and* Etouffée, Mon Amour: The Great Restaurants of New Orleans

Printed in China
Published by Pelican Publishing Company, Inc.
1000 Burmaster Street, Gretna, Louisiana 70053

CONTENTS

introduction

IF ARCHITECTURE IS FROZEN MUSIC, the French Quarter plays a symphony of three centuries and a myriad of cultures. Its strange, harmonic beauty could only have come about in a European outpost on the edge of the Caribbean at the dawn of the United States.

In 1718 French convicts cleared less than a mile of wet ground at a curve in the Mississippi River—the beginning of a colony that would become America's most romantic city, set to the tempo of horse-drawn carriages, tap dancers, and the adagio of the River herself.

Locals call it the Vieux Carré (French for "old square"), and for a hundred years the small grid comprised the whole city of New Orleans, with plantations and swamps on its outskirts. The

" Locals call it the **Vieux Carré "**

(French for "old square") . . .

old square today forms a window to the city's past. From the first French settlers who struggled against the waterlogged land, storms, fires, and yellow fever; to the Spaniards who wove their melody into the song of a French city; to African slaves, free people of color, Irish, English, German, and Sicilian immigrants—they all left their legacy in its hundred square blocks.

This book is a visual tour of the French Quarter, compiled from my books *Obituary Cocktail: The Great Saloons of New Orleans; The Majesty of the French Quarter;* and *Etouffée, Mon Amour: The Great Restaurants of New Orleans.* The properties here are sights you can capture from the street as you walk the old quarter's *banquettes.* Some of the city's famous restaurants and bars are also featured, as no trip to New Orleans would be complete with a cocktail and culinary tour!

Of course, many historic buildings and iconic establishments exist beyond the confines of the French Quarter. After a tour of the Vieux Carré, hop on a streetcar to take in the architectural delights of the Garden District and St. Charles Avenue, head across Rampart to see where jazz was born and St. Louis Cemetery Number 1 with the tomb of Voodoo queen Marie Laveau, or board a ferry across the Mississippi to Old Algiers. Adventures await around every corner!

" . . . for a hundred years the small grid comprised the whole city of New Orleans, with plantations "

and swamps on its outskirts.

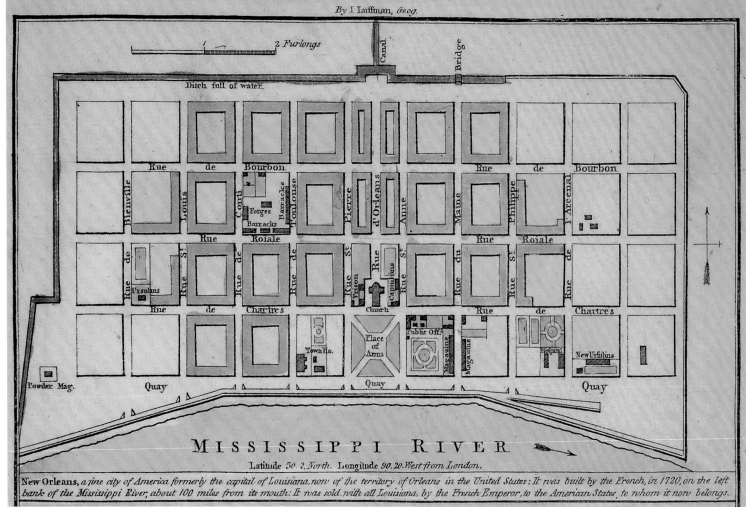

NEW ORLEANS.

By J. Luffman, Geog.

2 Furlongs

Canal

Bridge

Ditch full of water.

Rue de Bourbon Rue de Bourbon

Bienville Louis Conti Forges Barracks Toulouse Pierre d'Orleans Anne Maine Philippe l'Arsenal

Barracks

Rue Roiale Rue Roiale

Rue de Rue St. Rue de Rue de Rue St. Rue Prison Rue Capucins Rue St. Rue du Rue St. Rue de

Ursulins

Rue de Chartres Church Rue de Chartres

Town Ho. Place of Arms Public Off. Magazine Magazine Hospital New Ursulins

Powder Mag. Quay Quay Quay

MISSISSIPPI RIVER

Latitude 30. 2. North. Longitude 90. 20. West from London.

New Orleans, a fine city of America formerly the capital of Louisiana, now of the territory of Orleans in the United States: It was built by the French, in 1720, on the left bank of the Mississippi River, about 100 miles from its mouth: It was sold, with all Louisiana, by the French Emperor, to the American States, to whom it now belongs.

maps

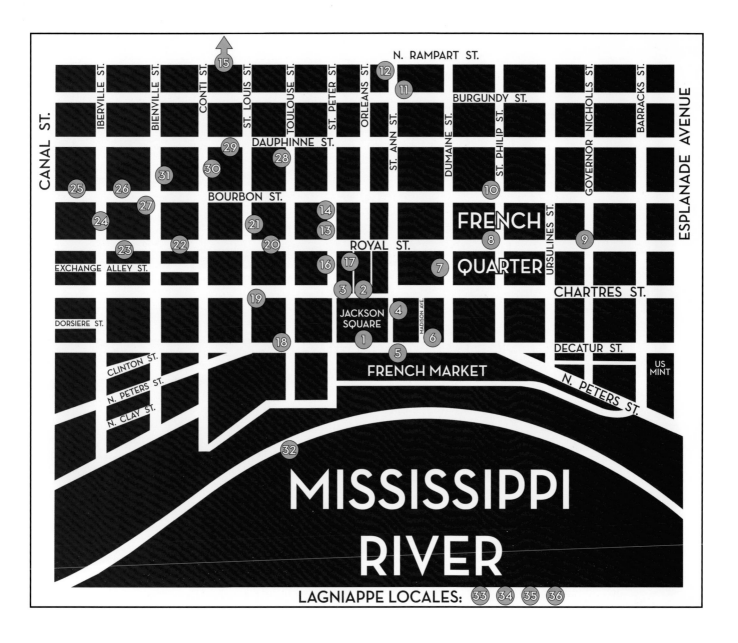

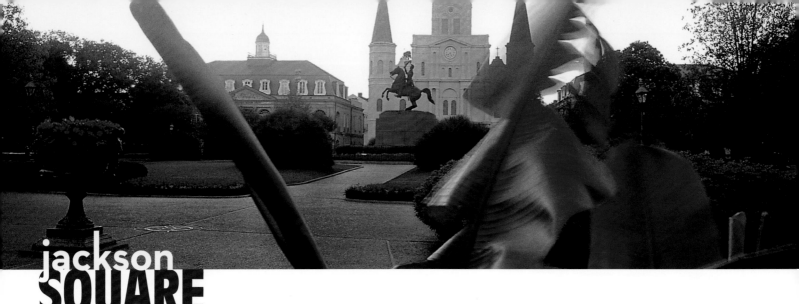

jackson SQUARE

THE PLACE D'ARMES, ORIGINALLY A MILITARY

parade ground, was renamed Jackson Square in 1851. The square has hosted the colony's official events for generations and today is a public garden, providing a backdrop for painters, jazz bands, and fortunetellers. The bronze statue of General Andrew Jackson on horseback rears before St. Louis Cathedral—a sight that signifies New Orleans the way the Eiffel Tower stands for Paris or the Alamo for San Antonio.

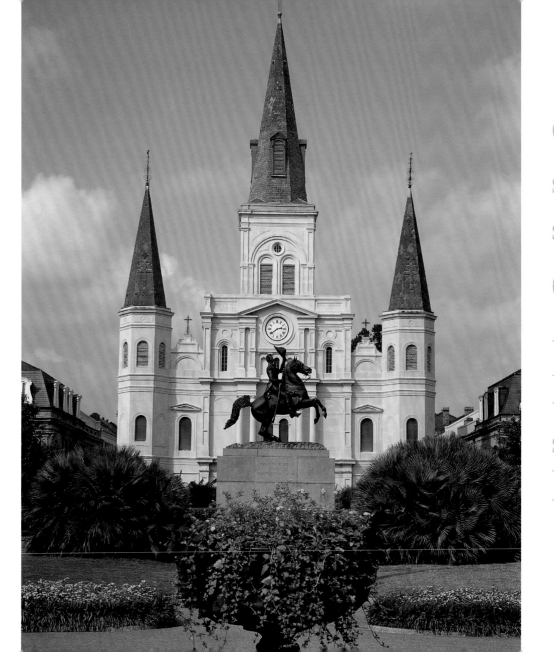

“ … St. Louis Cathedral—a sight that signifies New Orleans the way the Eiffel Tower stands for Paris … ”

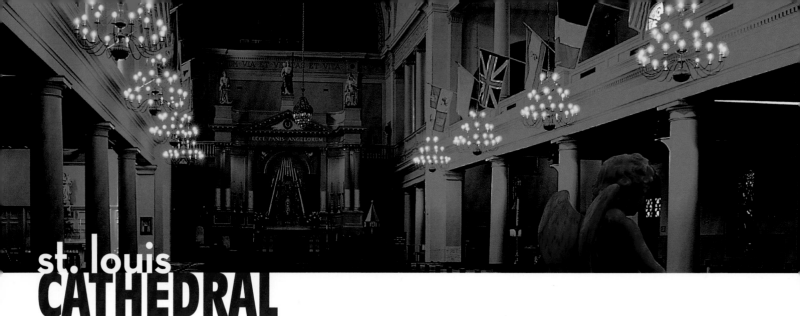

st. louis CATHEDRAL

IN THE ENTIRE LOUISIANA PURCHASE

territory, a chunk roughly one third of the United States, no great architecture existed until Gilbert Guillemard designed the St. Louis Cathedral, the Cabildo, and the Presbytère on the French Quarter's Place d'Armes. The current St. Louis Cathedral was rebuilt in 1852 by the prominent French architect J.N.B. dePouilly and reflects the Greek Revival style of the time.

St. Louis Cathedral bears the name of the patron saint of Bourbon, France. The first church on the site was destroyed by the hurricane of 1722, and prayers are still offered to Our Lady of Prompt Succor to save the city from destruction every hurricane season.

ABOVE: *St. Louis Cathedral from the river.*

Pere Antoine Alley

"...prayers are still offered to Our Lady of Prompt Succor to save the city from destruction every hurricane season."

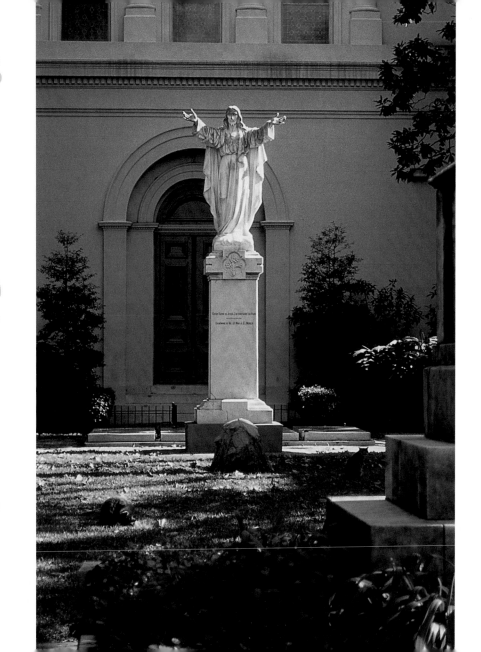

RIGHT: *The back of St. Louis Cathedral, 1852. French architect J.N.B. de Pouilly's version of Greek Revival.*

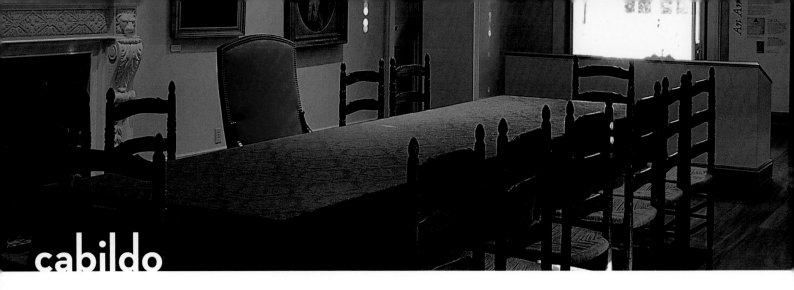

cabildo

NAMED FOR THE LOCAL SPANISH

governing body, the Cabildo is the most important building of the Spanish Colonial era. Completed in 1803, it incorporates bits of an earlier 1750s building. In the year of its completion, the Cabildo would see the Spanish, French, and American flags fly over the Place d'Armes. In the Cabildo jail, Jean Lafitte's brother and partner in crime, Pierre, was held in chains from April to September 1814 before escaping shortly before the Battle of New Orleans.

The Cabildo and its twin, the Presbytère, completed in 1813, now house exhibits of the Louisiana State Museum.

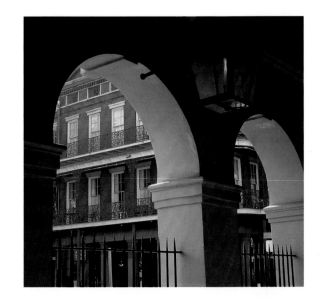

OPPOSITE: *The front arches of the Cabildo.*

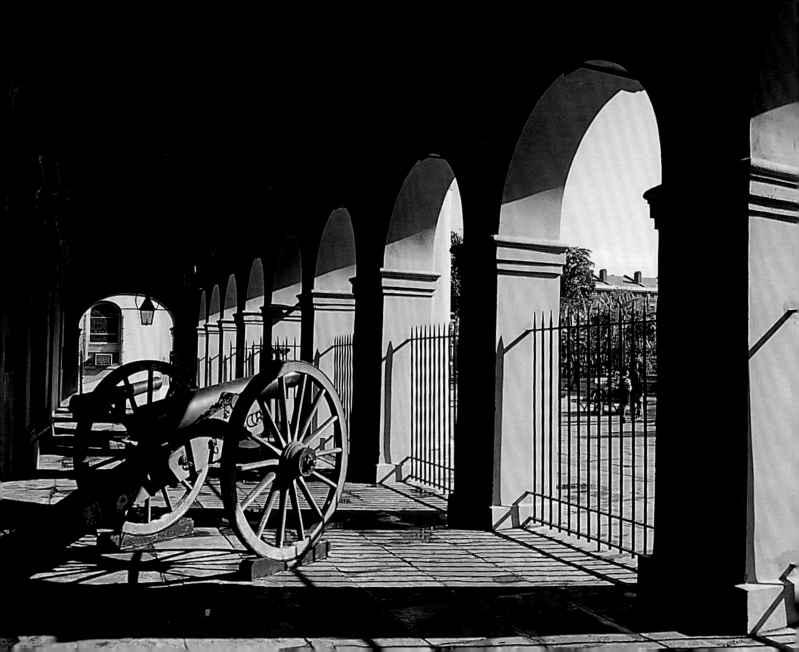

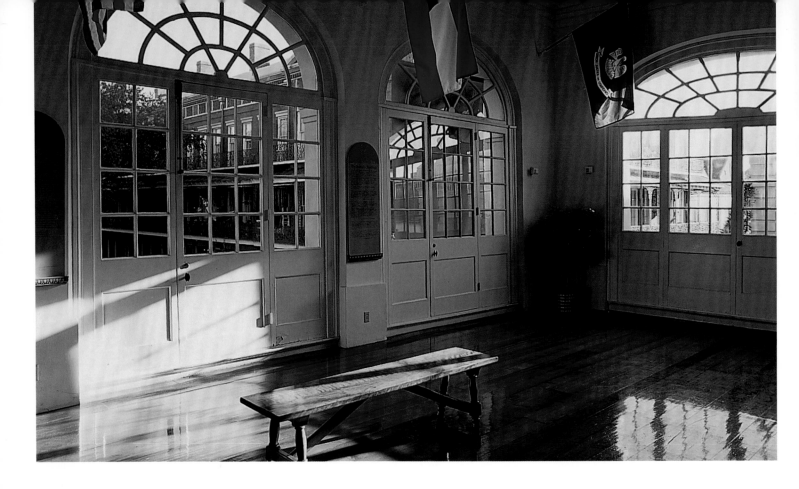

> " ... Jean Lafitte's **brother** and partner in

 Rue Chartres
Chartres

ABOVE: *The front hall of the Cabildo and the flags that flew over the city.*

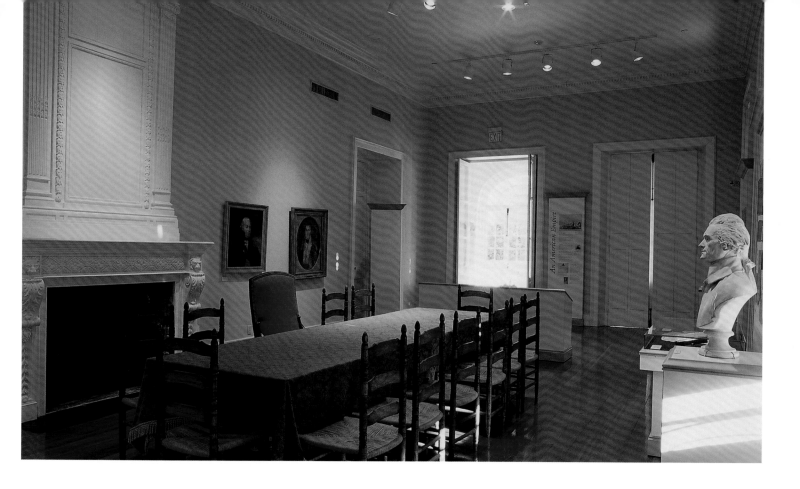

crime, Pierre, was held in chains ...

ABOVE: *In the Cabildo's Sala Capitular, the transfer of the colony resulting from the Louisiana Purchase was made official.*

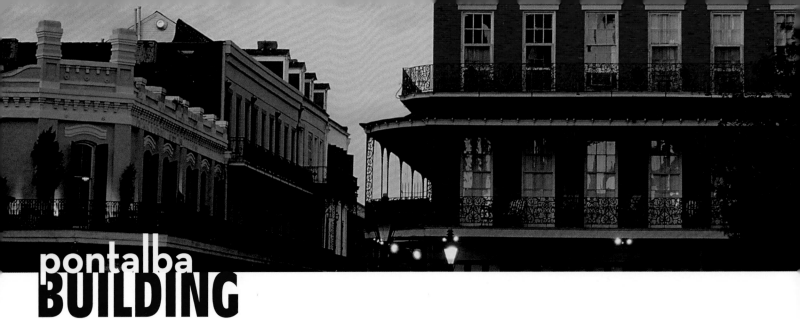

pontalba
BUILDING

JACKSON SQUARE WAS A FAMILY AFFAIR.

The Baroness de Pontalba, Micaela Almonester, worked with architects James Gallier, Sr., and Henry Howard to design Parisian-style apartments flanking Jackson Square. Her father, Andres Almonester de Roxas, funded the cathedral and the Cabildo half a century earlier.

In the 1850s, the Pontalba buildings changed the face of New Orleans with their bold new cast iron galleries. These verandas could be quite large because of their column-supports, unlike the wood or wrought iron balconies before them that were supported by the building.

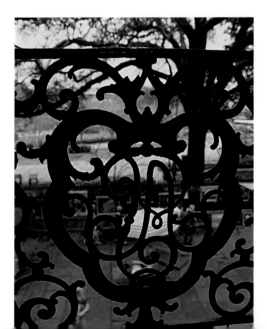

Rue Ste. Anne
St. Ann

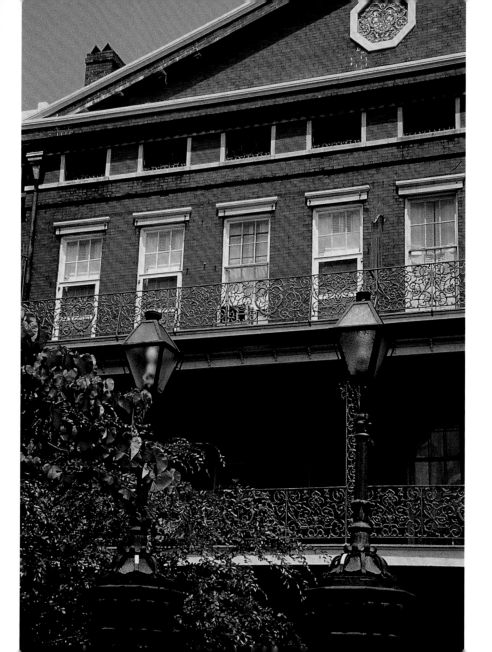

"... Parisian-*style* apartments flanking Jackson Square."

LEFT: *The Pontalba Building.*

OPPOSITE, BOTTOM: *The initials for Almonester and Pontalba intertwine in the cast iron balconies.*

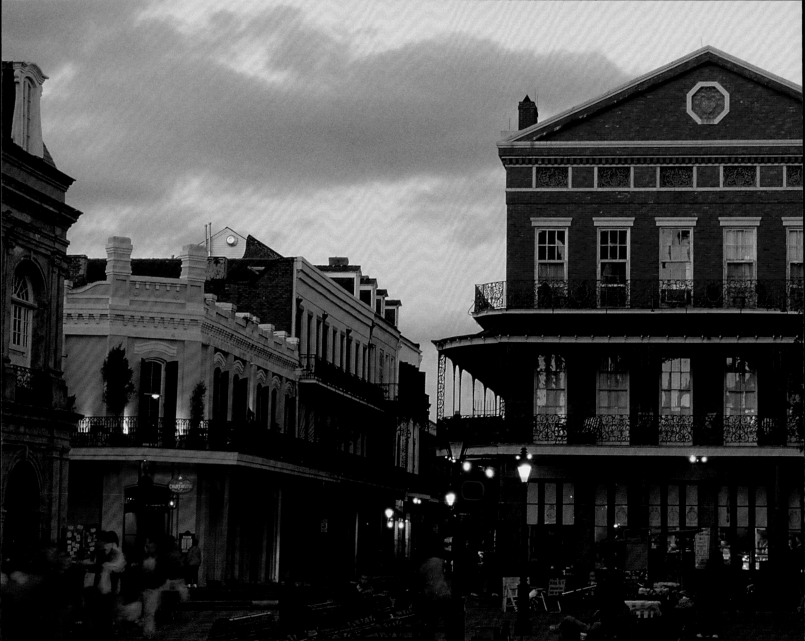

OPPOSITE: *The Pontalba buildings (on the right), inspired by Paris apartments, show Greek Revival influence with American red brick but maintain the Creole inner courtyard and commercial/ residential tradition, while the buildings across Chartres Street (on the left) retain the stuccoed fronts of an older Creole taste.*

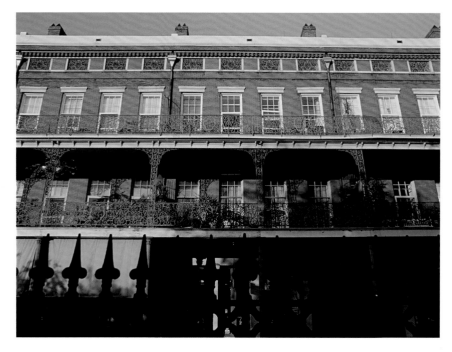

" ... the Pontalba buildings changed the face of New Orleans ... "

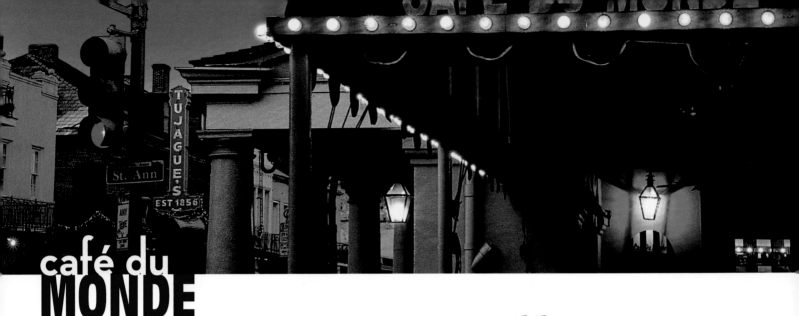

café du
MONDE

ALONG THE RIVER AT THE EDGE OF

Jackson Square, the French Market occupies a trading site established by Indians at the founding of the colony.

Café du Monde serves coffee and beignets in the oldest surviving French Market structure, built in 1813 by the eminent architect-builders Claude Gurlie and Joseph Guillot.

" . . . coffee and beignets in the oldest surviving French

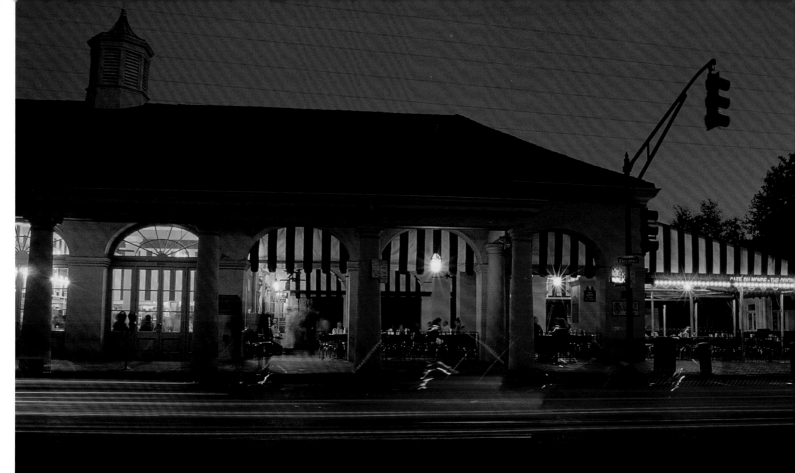

Market structure, built in 1813 . . . "

25

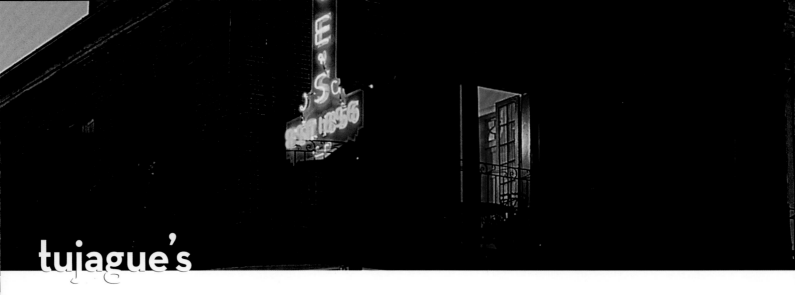

tujague's

TUJAGUE'S OPENED ACROSS THE STREET

from the French Market in 1856 to serve the local workers when Levee Street (now Decatur Street) was the center of New Orleans' commerce.

Built in 1827 on the site of an old Spanish armory, Tujague's still has an Old-World air, as the afternoon crowd of locals drifts in from the surrounding businesses and markets. The tall, mirrored back bar was already a century old when it was shipped from a Paris bistro to Guillaume Tujague's bar.

The building adjacent to the bar, now one of Tujague's dining rooms, was the restaurant of Madame Begue, who came to New Orleans from Bavaria in 1853 to win the heart of the city with her culinary talent.

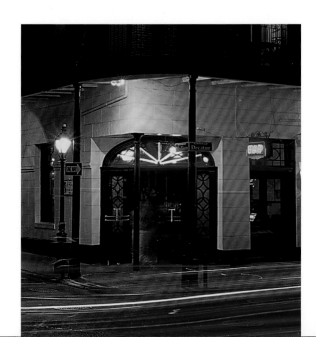

" Built in 1827 on the site of an old Spanish armory, Tujague's still has an Old-World air . . . **"**

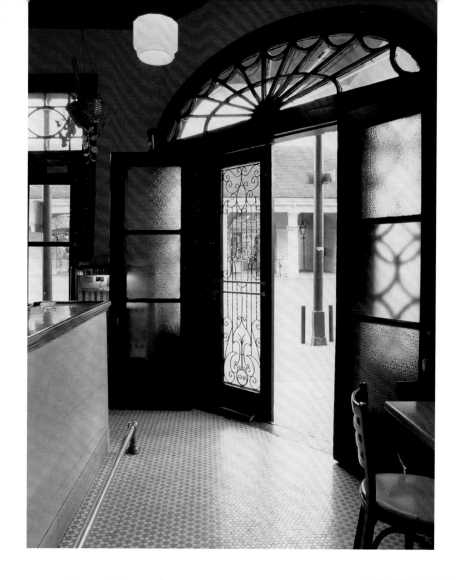

ABOVE: *Tujague's, New Orleans' original stand-up bar, opened in the middle of the nineteenth century.*

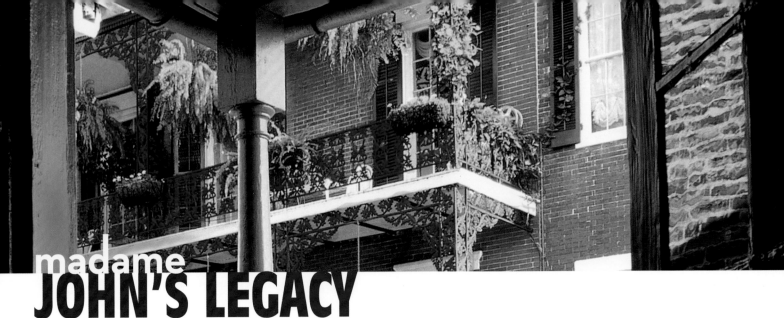

madame JOHN'S LEGACY

632 DUMAINE TYPIFIES FRENCH

Colonial architecture of New Orleans' early days. This plantation-style house, with a raised basement and steep roof, emerged in subtropical climates. Every room opens onto wide verandas in front and back. This type of veranda had canvas flaps that could be rolled down to close the area completely in bad weather or hot sun.

The house became known as Madame John's Legacy after George Washington Cable used it as the home of a fictional character in his short story, "'Tite Poulette." Cable's writing introduced a large audience to the exotic city of New Orleans in the late nineteenth century, and many buildings are remembered more for their fictional inhabitants than for the real ones.

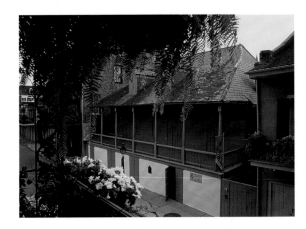

ABOVE: *Madame John's Legacy is now a part of the Louisiana State Museum.*

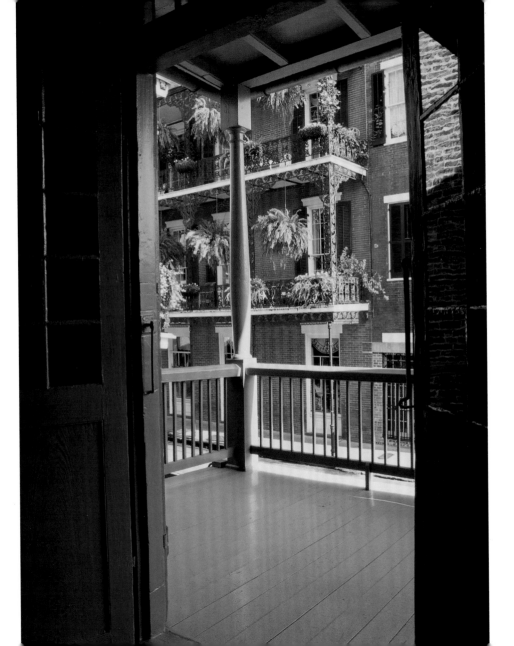

" Cable's **writing** introduced a large audience to the **exotic** city of **"** New Orleans . . .

LEFT: *Front gallery of Madame John's Legacy.*

gallery ROW

THE BALCONIES OF "GALLERY ROW" EVOKE

images of the hanging gardens of ancient Mesopotamia, dangling lush greenery over Royal Street. Rue Royal has been a fashionable commercial avenue since the early 1800s. Collectors from around the world come to New Orleans to savor Royal Street's antique shops and galleries.

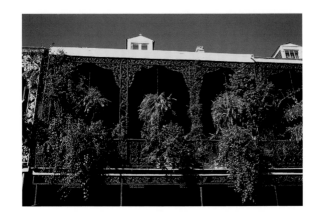

ABOVE: *An 1831 Creole townhouse.*

" . . . images of the hanging gardens of ancient Mesopotamia, dangling lush greenery . . . **"**

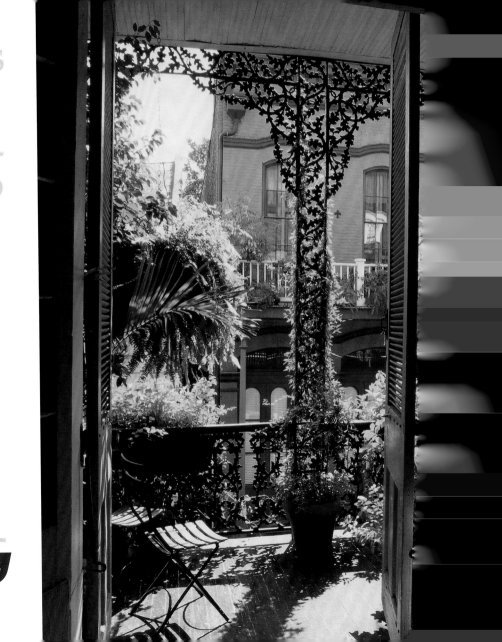

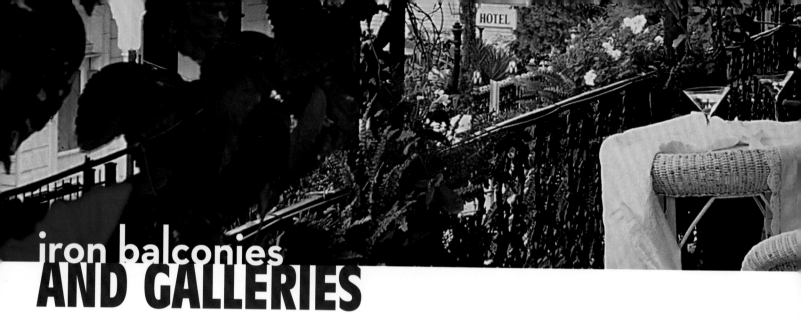

iron balconies
AND GALLERIES

TODAY'S VIEUX CARRÉ REFLECTS FRENCH

building practices of the seventeenth century with an openness that evolved as the architecture responded to the rainy and hot environment.

The forty years of Spanish possession blew through the colony like a sultry breeze and left as its signature the most romantic of spaces—exquisite balconies and glorious courtyards.

Throughout Spanish Colonial times, wrought iron railed balconies were imported from Spain and Mexico or forged in New Orleans.

Huge ornamental cast iron galleries were added to many existing buildings in the 1850s, extending living space out over the sidewalks.

Examples of all kinds of balconies and galleries hang

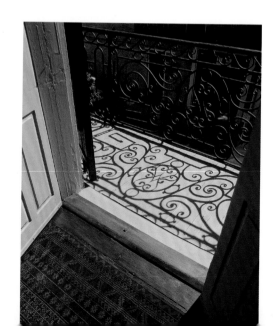

32

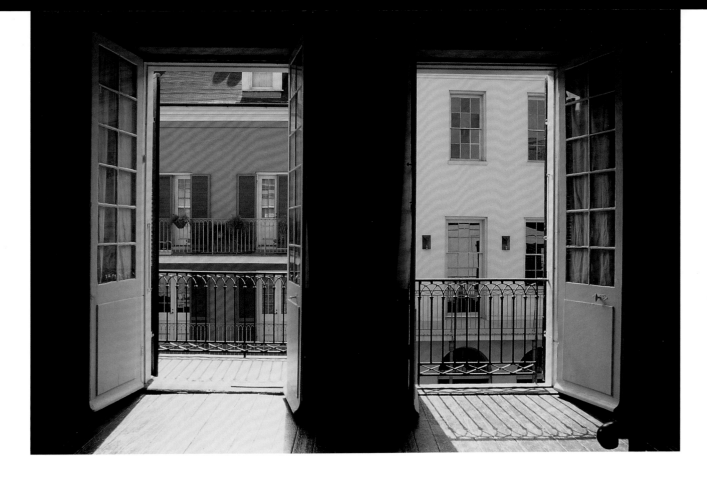

daintily from buildings or stand audaciously over the street today, providing a premium French Quarter view.

OPPOSITE: *The Casa Correjolles shows the finest example of early wrought iron craftsmanship.*

ABOVE: *The dainty wrought iron railings of the Chesneau House, circa 1800.*

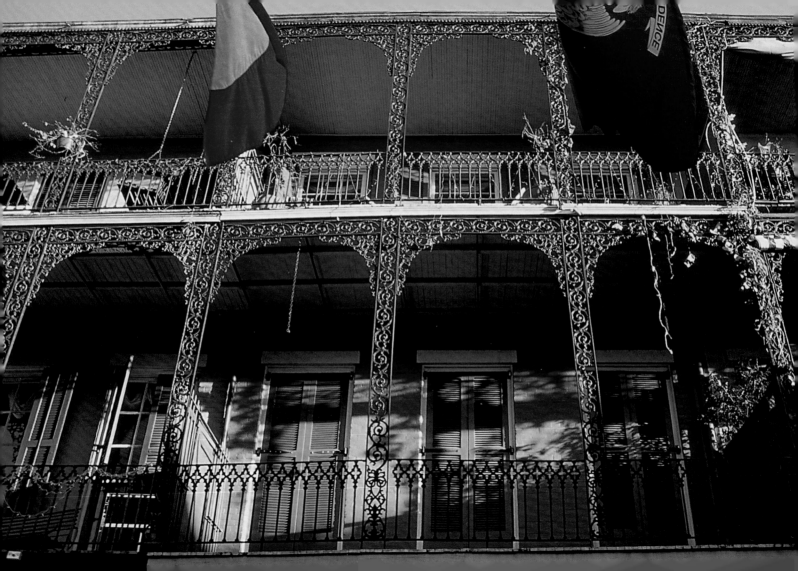

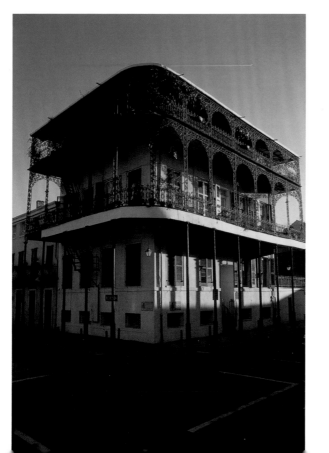

" ... balconies were imported from Spain and Mexico ... "

OPPOSITE: *The 1840 Kohn Building, 920 Royal Street, received its galleries in the 1850s.*

TOP: *800 Royal Street. This house has a wrought iron upper balcony and a cast iron lower balcony facing the street.*

BOTTOM: *At the corner of Dauphine Street and Ursuline Street, the Gardette-LePretre House went up in 1836 but was without galleries until the 1850s.*

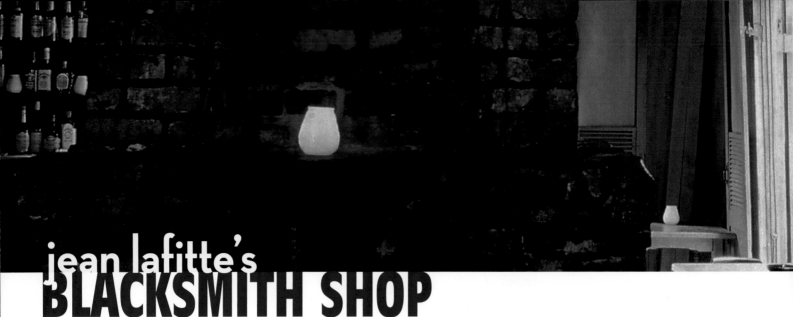

jean lafitte's
BLACKSMITH SHOP

WITH TRAP DOORS AND HIDDEN SPACES,

the Blacksmith Shop's rooms of aged bricks and cypress beams have stood since 1772.

For generations, New Orleans relied on privateering for essentials that were over-priced or unobtainable otherwise. The pirate Lafitte brothers, Jean and Pierre, were local heroes. Their clients were rich men, gentry, and plantation owners. Their most lucrative cargo was slaves.

The Lafittes came to Louisiana around 1800 via the West Indies and operated an ironworks at the corner of Bourbon and St. Philip Streets as a cover for their smuggling operation. A respectable facade, the forge at the blacksmith shop still works and may have turned out lace-iron balconies like

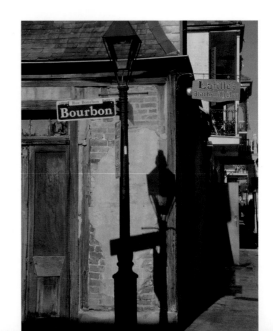

" …rooms of **aged brick** and **"** cypress …

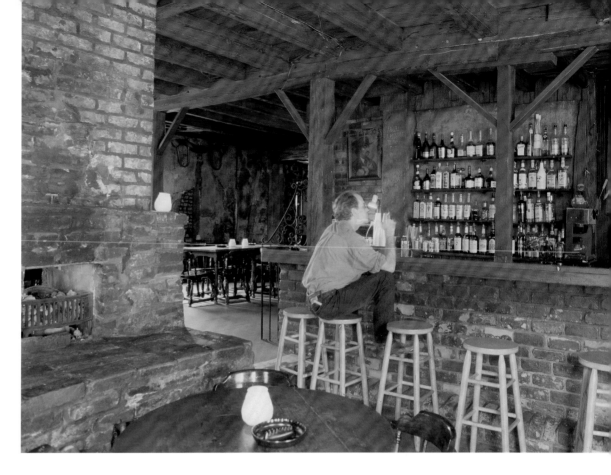

those in the area today.

Lafitte's is the second oldest building in New Orleans, having survived numerous hurricanes and the fires of 1788 and 1794 that destroyed a majority of the early French Quarter buildings. It has been a bar since the mid 1800s, making it one of the oldest saloons in the United States.

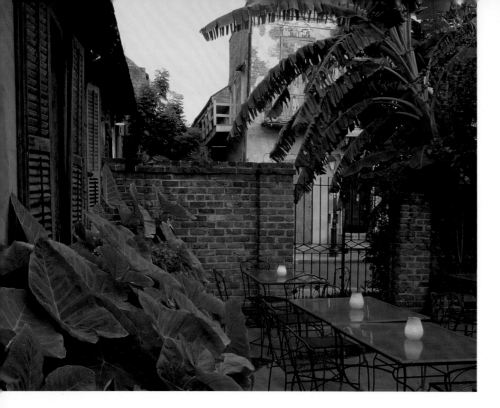

ABOVE: *Around the beginning of the twentieth century, America invented the ultimate cocktail—the martini. Lafitte's Blacksmith Shop made a special version with an added splash of absinthe and called it the Obituary Cocktail.*

OPPOSITE: *This Creole cottage, now serving as a bar, was constructed when New Orleans' population of about 3,000 covered only the French Quarter.*

" … as a cover for their smuggling operation. **"**

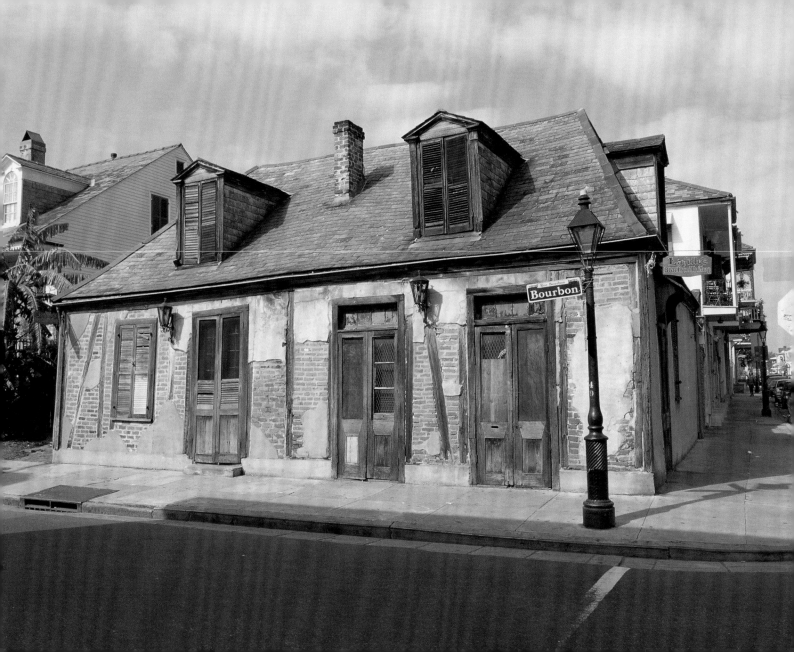

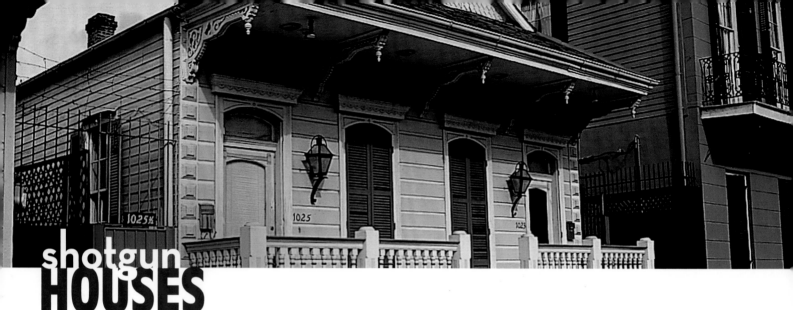

shotgun HOUSES

HOUSES IN THE VIEUX CARRÉ FALL

roughly into five categories: the Creole cottage, the Spanish Colonial house, the townhouse, the shotgun house, and various service structures. But the buildings refuse to follow strict chronological order.

In the post-Civil War depression the shotgun house became popular all over New Orleans. Its long, skinny shape, probably from the West Indies, squeezed perfectly into the ever-narrowing lots of the French Quarter.

"...squeezed perfectly into the ever-narrowing lots of the French Quarter."

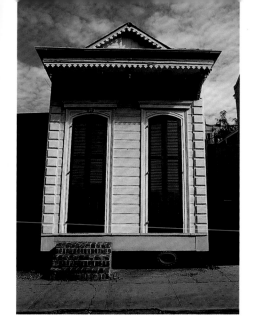

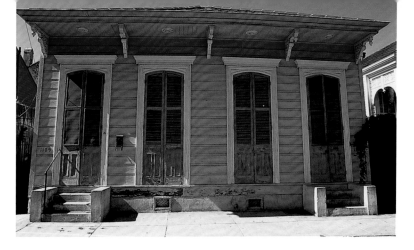

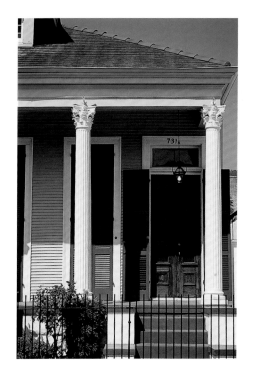

TOP LEFT: *Shotgun single.*

TOP RIGHT: *An 1890s shotgun double.*

BOTTOM RIGHT: *A shotgun with a Classical Revival flourish built around 1910.*

BOTTOM LEFT: *The back door of a typical shotgun.*

honoring the
ARCHITECTURAL TRADITION

IN THE MODERN FRENCH QUARTER

renaissance, there is a new admiration for the artful forms of architectural features whose functionality has long passed. Careful renovations bring into the twenty-first century rooms that were designed before electricity and plumbing.

Historians have scraped through the centuries to find original paint colors, so that French Quarter streets are again a parade of reds and yellows shuttered in Napoleon blue or Paris green.

" . . . a parade of **reds** and yellows shuttered in

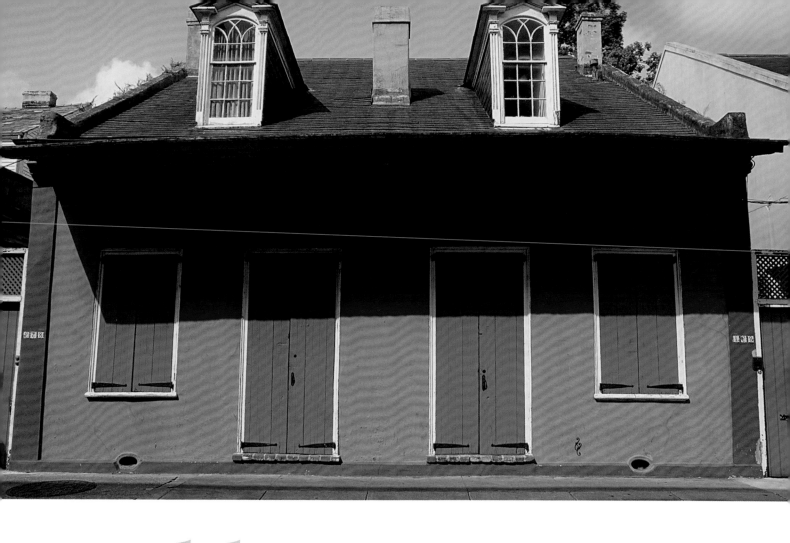

Napoleon blue or Paris green."

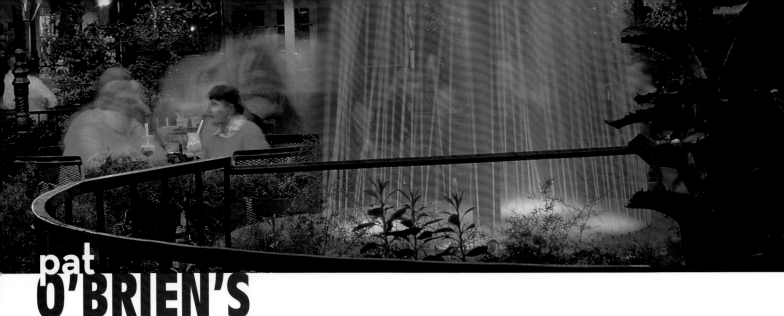

pat
O'BRIEN'S

IF THEY SURVIVED THE PERILOUS 1,000-MILE

Gulf crossing from Belize and escaped attack by hijackers, Prohibition era rum-runners got rich supplying New Orleans' hooch. For more than twelve years, these tactics supplied drinks for the city's illegal bars, or speakeasies, like the Club Tipperary said to be run by Benson Harrison "Pat" O'Brien. Not far from Pat O'Brien's current location, the Club Tipperary served clients who knew the passwords, "Storm's Brewin'."

O'Brien's official story has it that he was broke and passing through New Orleans on his way to take a job in Texas in 1935. He fell in love with the city and saw potential for the fun business in the post-Prohibition Big Easy. Either way, O'Brien and his

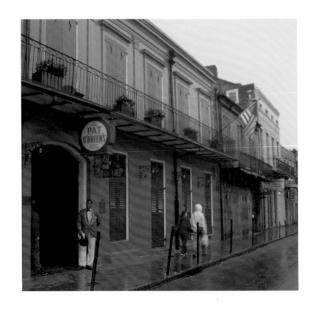

Rue St. Pierre
St. Peter

"...supplied drinks for the city's illegal bars, or" speakeasies ...

partner Charlie Cantrell opened a bar in the present location in 1942, now the celebrated den of nonstop merriment.

OPPOSITE, BOTTOM: *The 1817 porte cochére house with its central carriage-way entrance.*

RIGHT: *Colonial-era muskets hang above the entryway.*

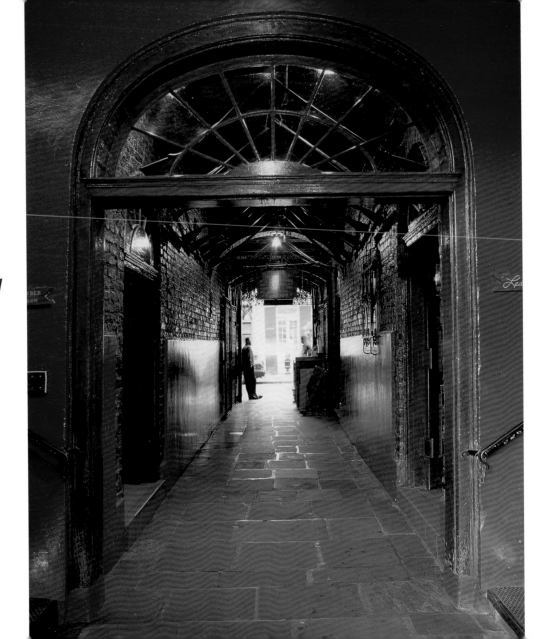

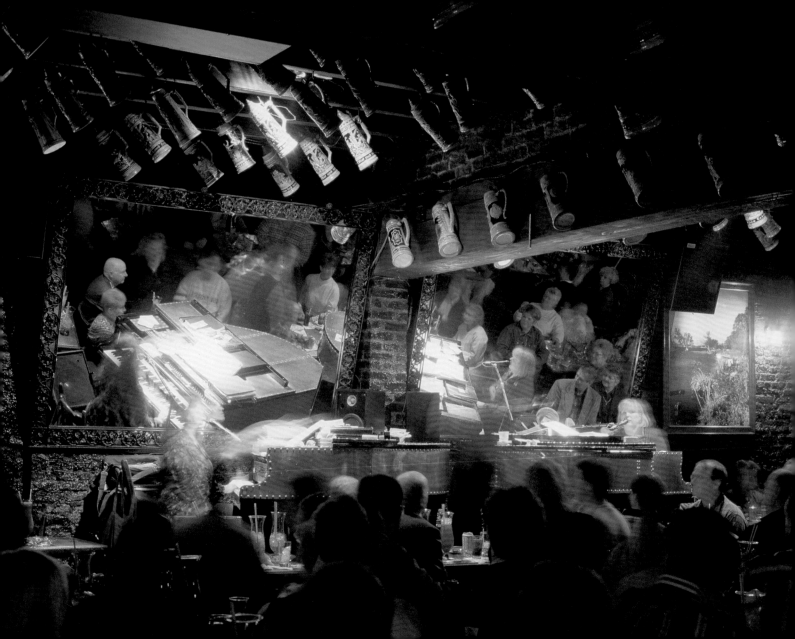

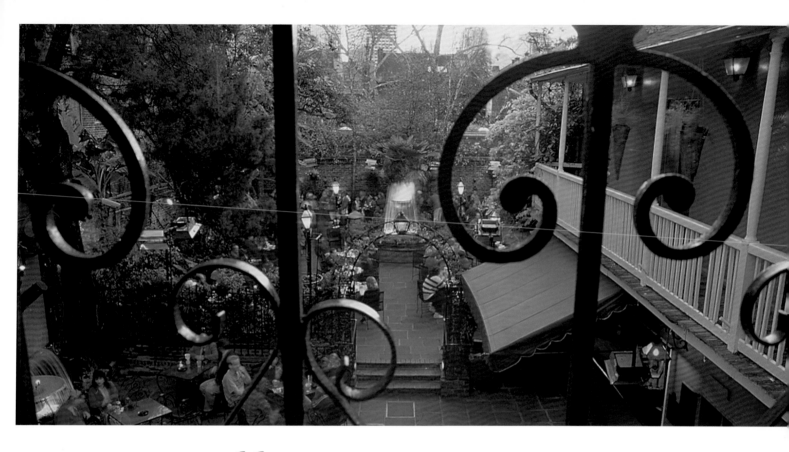

OPPOSITE: *Two grand pianos and tons of rum are the ingredients of Pat O'Brien's party 365 days a year. The mug collection started in the 1930s when Charlie Cantrell visited Germany and returned with traditional steins that he hung on the ceiling of the main bar.*

" …clients who knew the passwords, "Storm'sBrewin'." "

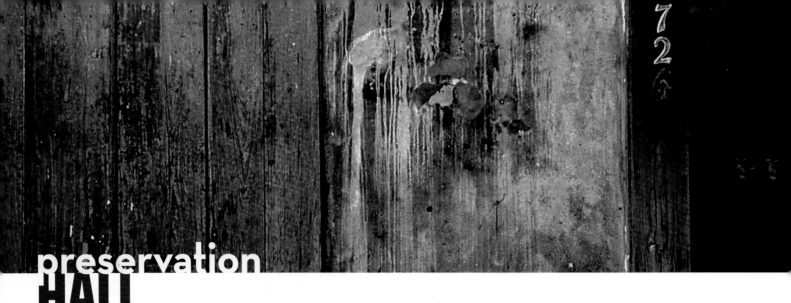

preservation
HALL

IN THE POWERFUL SPELL OF NEW

Orleans, time slows, the outside world vanishes, and an unplanned and ever-changing gallery of shapes and colors grows from the ground, crumbles from the walls, or stretches with the setting sun.

" . . . time slows, the outside world vanishes . . . **"**

BELOW: *The weathered front of Preservation Hall, an 1817 townhouse and world-famous traditional jazz venue.*

Rue St. Pierre
St. Peter

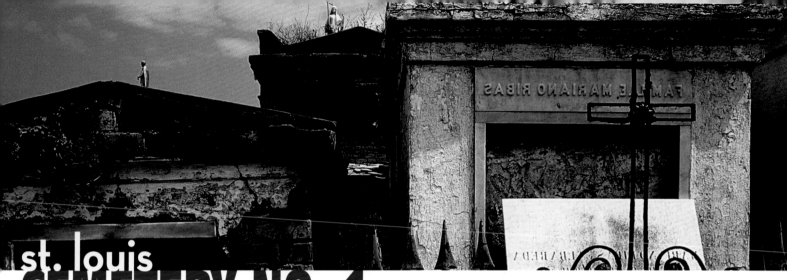

st. louis
CEMETERY NO. 1

GRAND TOMBS ADORNED WITH IMPORTED

marble and fresh flowers stand beside collapsing ruins of bare brick and stucco. The architecture of St. Louis Cemetery echoes the French Quarter on a smaller scale. St. Louis Cemetery No. 1 opened on the edge of the French Quarter in 1788, and it was here that above-ground crypts first appeared. Before 1788 the dead were buried on the riverbank or in a graveyard that existed near St. Peter and Burgundy. The tombs of St. Louis Cemetery No. 1 are footprints of history, a chronicle of the region's wars, plagues, economy, and spirituality.

" ...a chronicle of the region's... **spirituality. "**

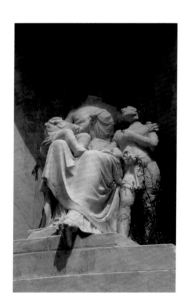

LEFT: *On a society tomb in St. Louis Cemetery, a sculpture succumbs to the elements.*

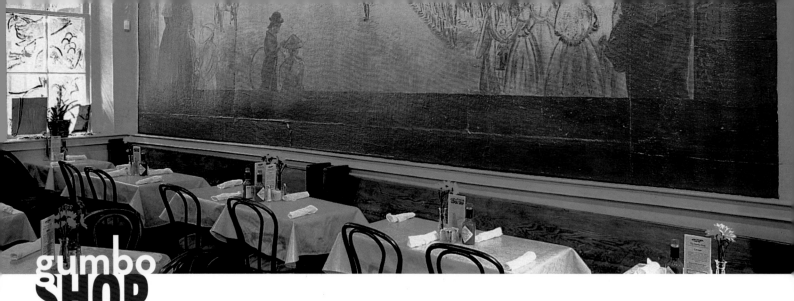

gumbo SHOP

IN ONE OF THE VIEUX CARRÉ'S OLDEST

buildings, one of the city's famous restaurants has been serving quintessential Creole food since 1945. The Gumbo Shop, founded by Margaret Popora, spreads throughout a 1795 Creole townhouse, its slave quarter, carriageway, and courtyard.

Merchant Pedro Commagere constructed the building, half a block from Jackson Square, to house a business on the first floor and residence above.

"... one of the city's famous restaurants ..."

Rue St. Pierre
St. Peter

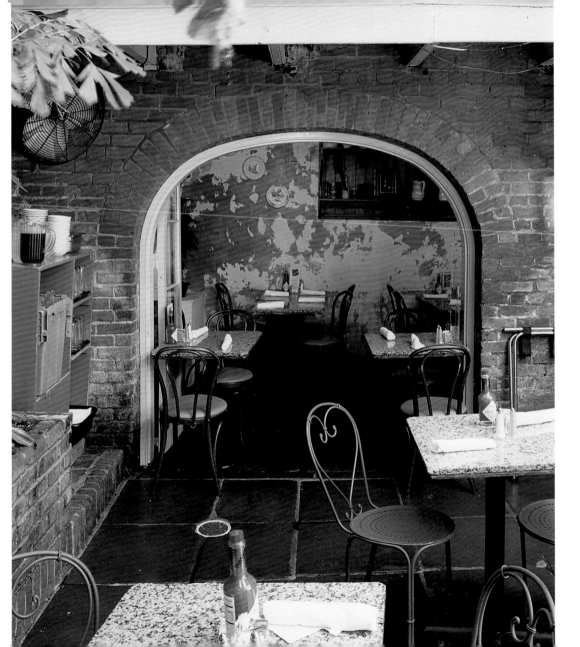

"The Gumbo Shop, founded by Margaret Popora spreads throughout a 1795 Creole townhouse . . ."

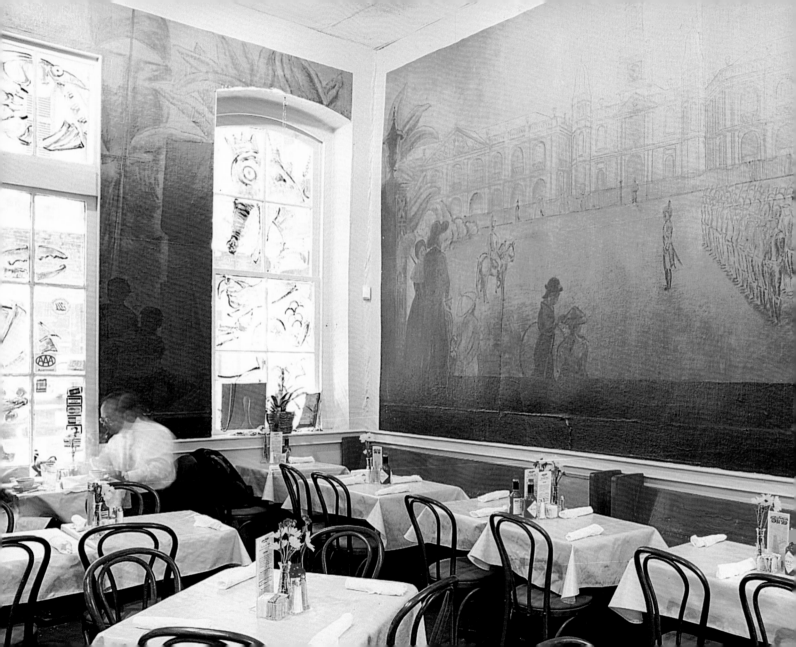

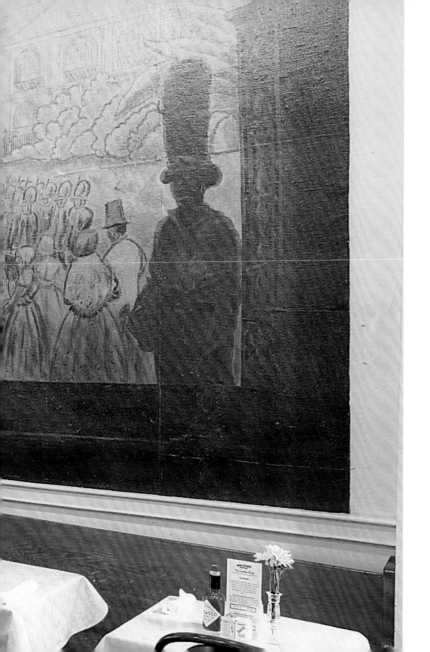

"...serving quintessential Creole food since 1945."

LEFT: *Artist Marc Anthony created the mural in the main dining room in 1925. The scene, painted on the burlap covers of cotton bales, depicts an early nineteenth-century military formation in Jackson Square when it was still the Place d'Armes, before the statue of Andrew Jackson was placed in the center of the gardens in 1856.*

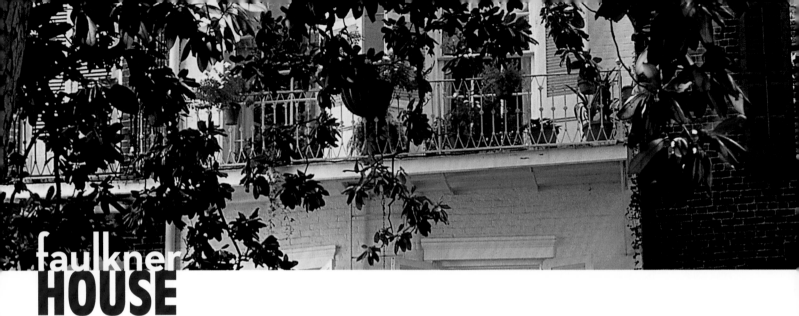

faulkner HOUSE

"…ALL IN HER HOUSE IS DIM AND BEAUTIFUL

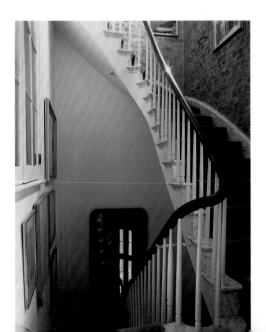

with age. She reclines gracefully upon a dull brocade chaise-lounge, there is the scent of incense about her, and her draperies are arranged in formal folds. She lives in an atmosphere of a bygone and more gracious age."

—William Faulkner,
"New Orleans Sketches," 1925

Behind St. Louis Cathedral, along Pirates' Alley, William Faulkner lived in an apartment in the 1840 LaBranche buildings, where he wrote his first novel, *Soldier's Pay*, and a series for the *Times-Picayune* called "New Orleans Sketches."

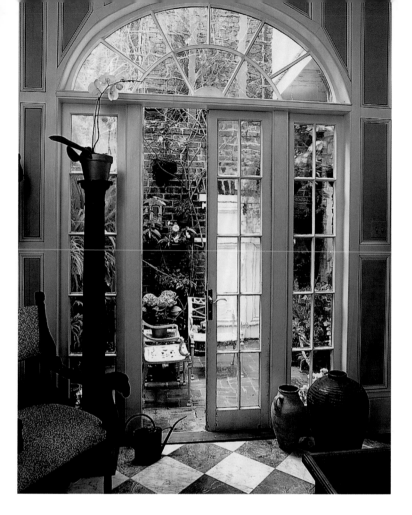

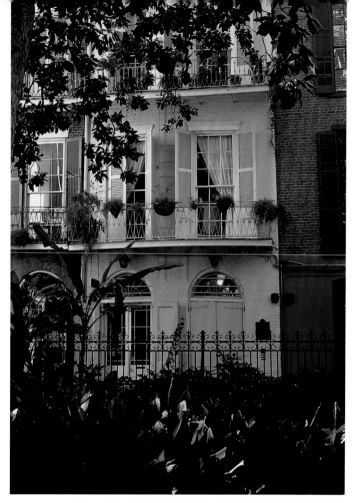

TOP LEFT: *The Faulkner House winds playfully up four stories around a tiny courtyard, each floor with its own color and personality.*

 . . . his **first** novel, *Soldier's Pay*. . .

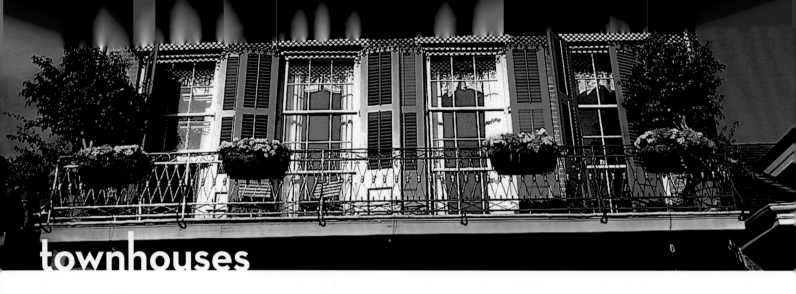

townhouses

THE CREOLE TOWNHOUSE IS A SPANISH

Colonial house with a plan. More compact and regularized, the townhouse evolved in the early nineteenth century. The early Creole townhouse makes the most of its space with two stories—commercial on the first floor and residential above. A walkway or carriageway leads to the courtyard, where an exterior stair leads to upper floors. A service wing along the side of the lot forms an L-shape. In many townhouses an entresol, or intermediate second floor lit by the tops of arched windows, accommodates storage.

Townhouses sprung up all over the French Quarter as New Orleans' population doubled several times in the first half of the nineteenth century. In the 1830s plantation owners splashed their wealth

> " ... splashed their **wealth** around town, constructing grand-scale townhouses ... "

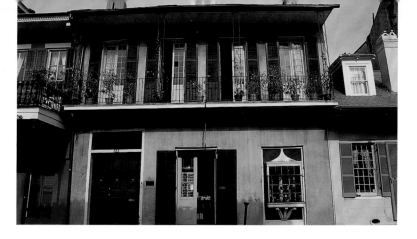

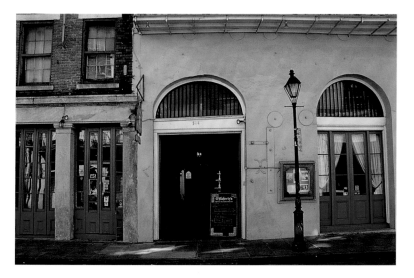
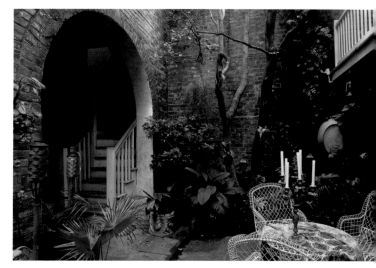

ABOVE: *The 1808 Nicholas House (top left). The back of an 1830 Decatur Street row house (top right) built by Gurlie and Guillot as rental property for the Ursuline nuns. This 1820 Toulouse Street house (bottom left) shows both a porte-cochère and an entresol. The couryard of the Burnett Townhouse (bottom right).*

"...like their traditions, **Creole** elements *steadfastly* **"** remained.

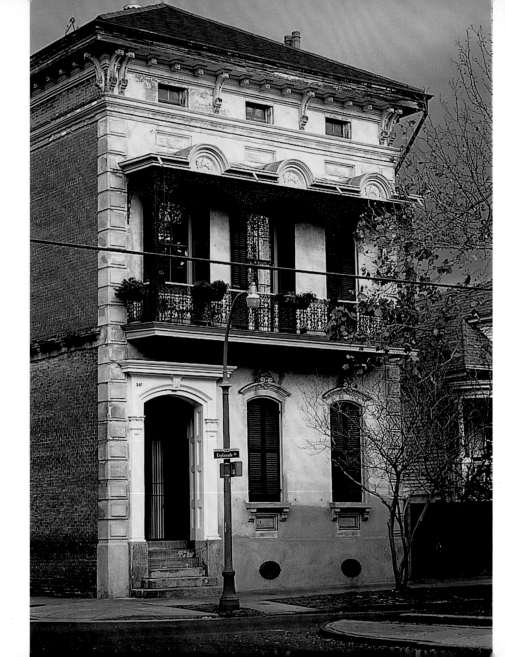

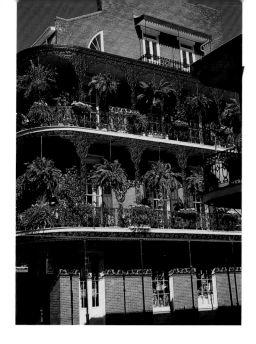

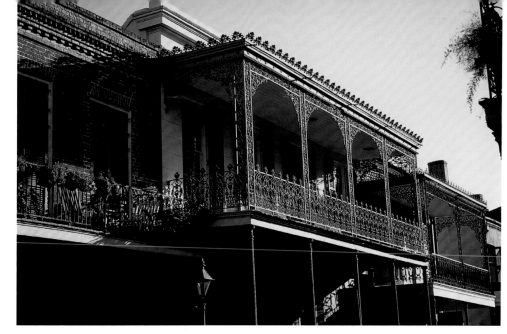

around town, constructing grand-scale townhouses for their visits to the big city. Americans added interior stairways and side halls. Still, like their traditions, Creole elements steadfastly remained.

TOP LEFT: *This four-story townhouse and the two homes next to it were built in 1838 for the family of Dr. Christian Miltenberger, who served as a surgeon at the Battle of New Orleans.*

TOP RIGHT: *One of New Orleans' most important architects, James Gallier, Jr., designed his own house in the French Quarter in 1857, a creative combination of the Creole and American townhouse in Greek Revival style.*

the napoleon
HOUSE

"GLORY IS FLEETING BUT OBSCURITY IS FOREVER."

—Napoleon Bonaparte I

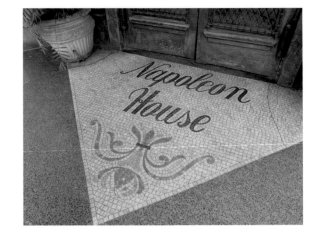

In 1821, Napoleon was in exile after his defeat at Waterloo. A former mayor of New Orleans, Nicholas Girod, decided that Napoleon, at age fifty-one, could still reshape the world, with Louisiana at the center. Girod financed a plot with Lafitte's right-hand pirate, Dominique You, to liberate their hero from the island of St. Helena.

A ship, the *Saraphine*, was built to royal proportions to rescue the Emperor, and a house—the present day Napoleon House—was prepared in the French Quarter to host the famed general. Three days before the ships were to leave New Orleans, word came of the

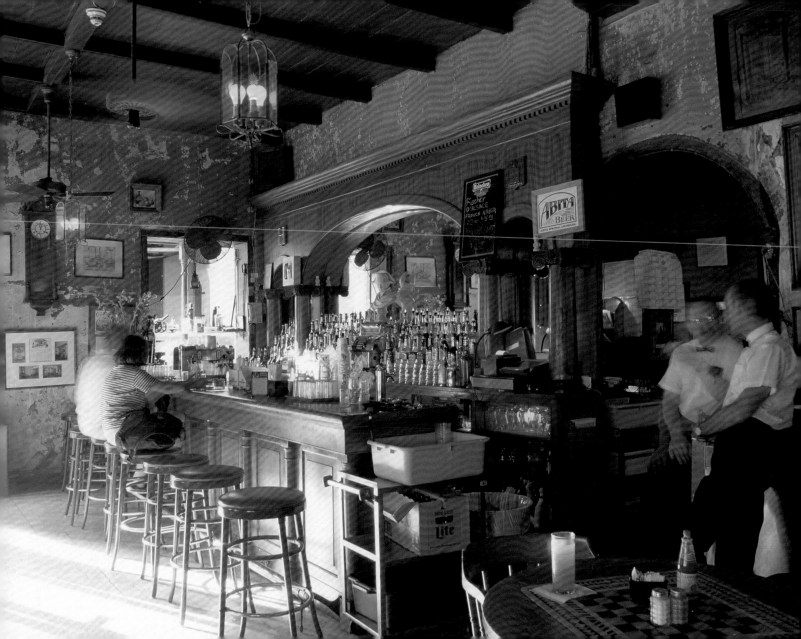

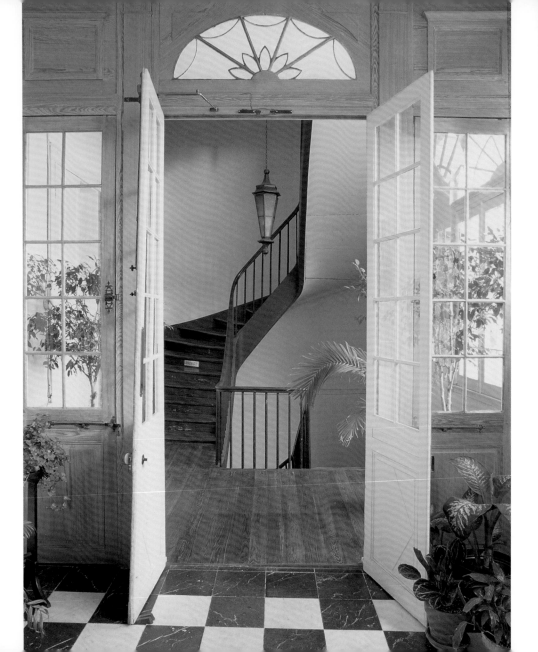

fate that had befallen the emperor. Bonaparte died while still on the island. He never saw the house that awaited him in the French Quarter.

The Impastato family took over a corner grocery at this location in 1914 and in 1940 opened the bar still run by the family today.

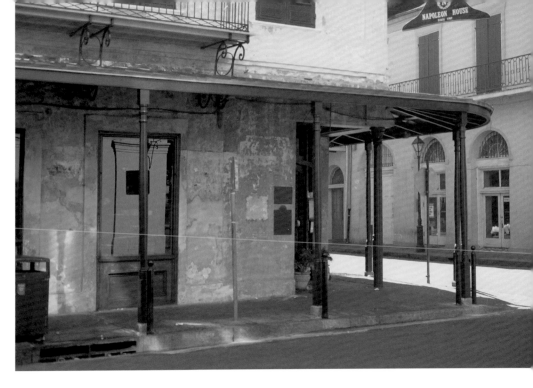

"... Napoleon ... could still reshape the world, with Louisiana at the center."

ABOVE: *The Impastato family took over a corner grocery at this location in 1914 and in 1940 opened the bar, still run by the family today.*

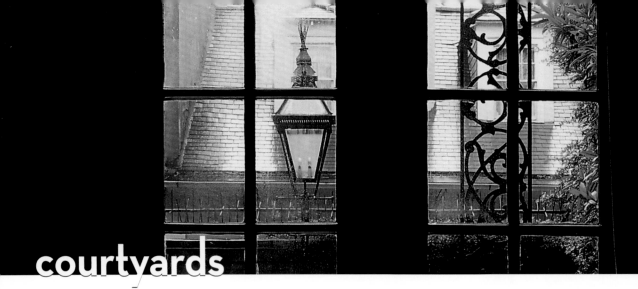

courtyards

THE FIRST RESIDENTS OF THE CITY, IN

urban-European style, built houses right at the sidewalk, or banquette, and walled the spaces between. The French Quarter's blocks, still closed from the outside, form an outer wall giving protection from intruders and hurricanes, and hiding the secret majesty within. The beauty of Vieux Carré homes is focused at the rear, in contrast to the grand front entrances and lawns of St. Charles Avenue.

While activity along French Quarter streets at times borders on the chaotic, the back garden remains a quiet paradise.

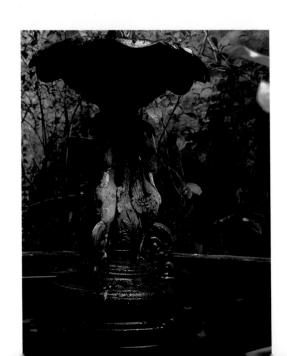

RIGHT: *A fantastic fountain in the courtyard of the Girod House, now the New Orleans Pharmacy Museum.*

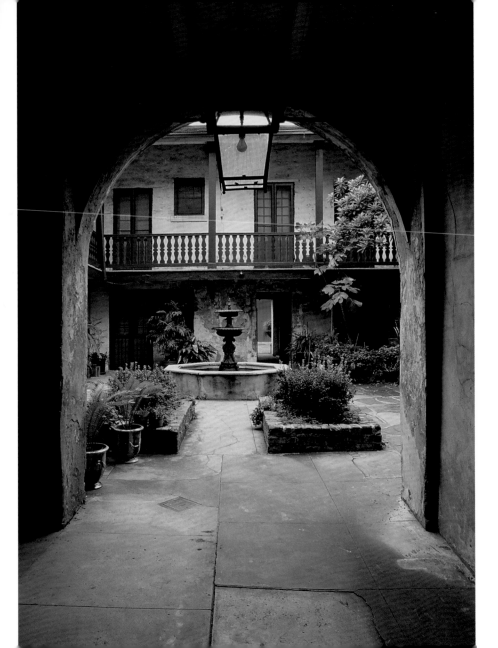

"...hiding the secret majesty within."

LEFT: *The Bosque House surrounds a grand courtyard entered through the carriageway, or porte-cochère.*

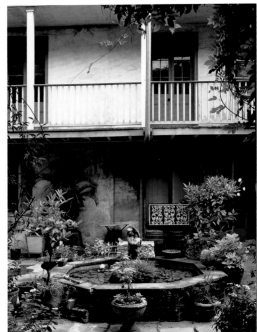

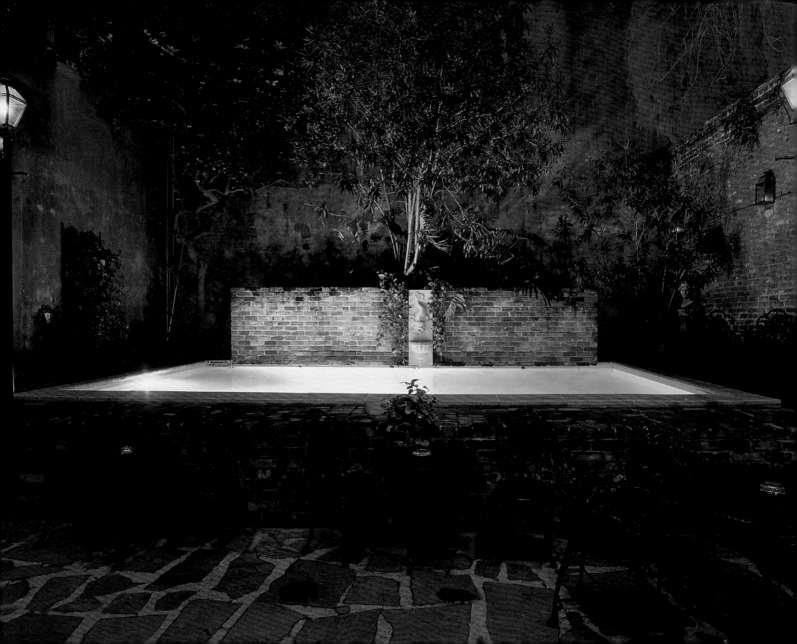

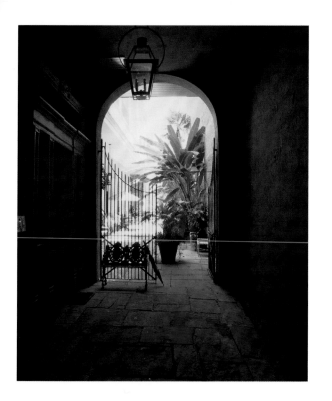

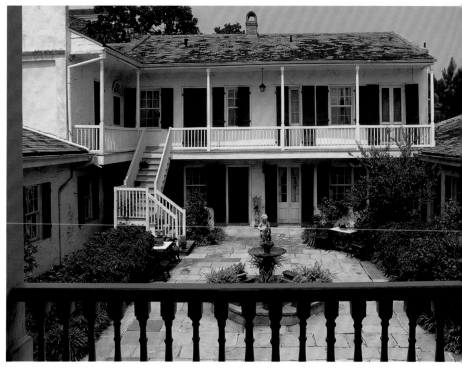

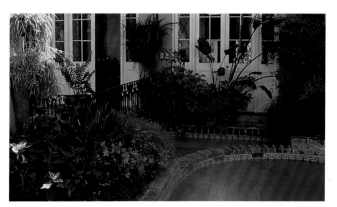

OPPOSITE: *The courtyard pool of the Hotel Ste. Helene.*

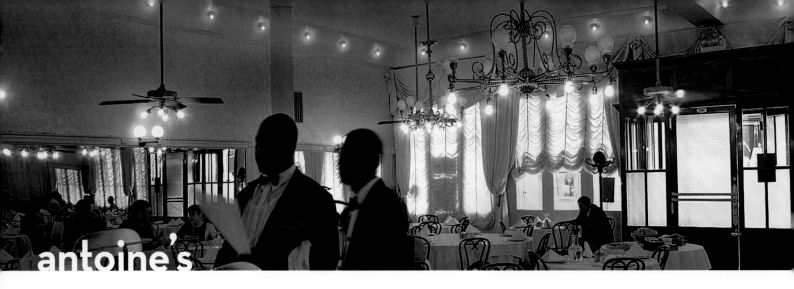

"WHEN YOU WANT REAL FOOD GO TO

Antoine's—when you want real life go to New Orleans."

—Herber Hoover II

There is no place like it. Antoine's may be the most famous restaurant in the world. It is the second-oldest restaurant in America, and the oldest still run by its original family. Its founder, Antoine Alciatore, has been credited with practically inventing Creole cooking. The restaurant's oysters Rockefeller has been called one of the great culinary creations of all time and America's single greatest contribution to haute cuisine.

RIGHT: *Antoine's, the South's oldest restaurant, opened in 1840 and still serves French Creole dishes in an 1831 mansion.*

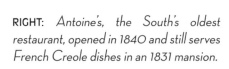

Rue St. Louis
St. Louis

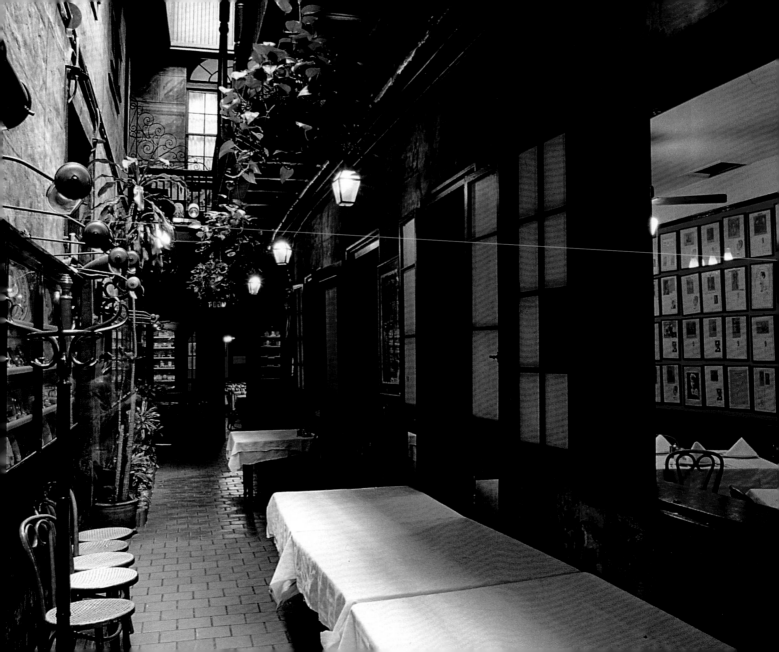

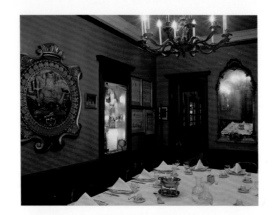

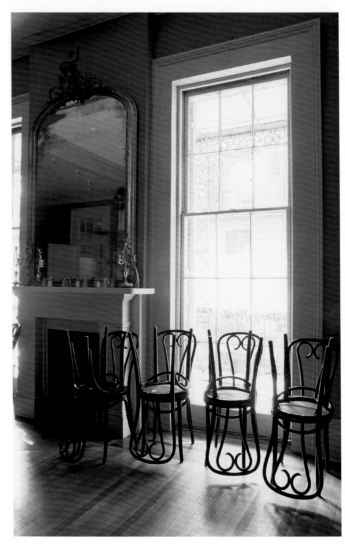

BOTTOM LEFT: *Antoine's President's Room—where eight U.S. presidents have dined over the years, six while in office.*

RIGHT: *The Twelfth Night Revelers room, above the main dining room, is the newest addition, remodeled from the old pension accommodations. It honors New Orleans' second-oldest Carnival club, established in 1870.*

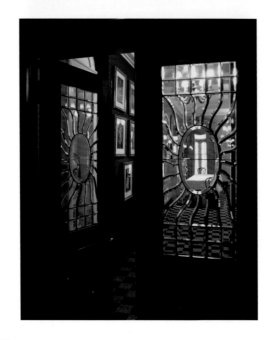

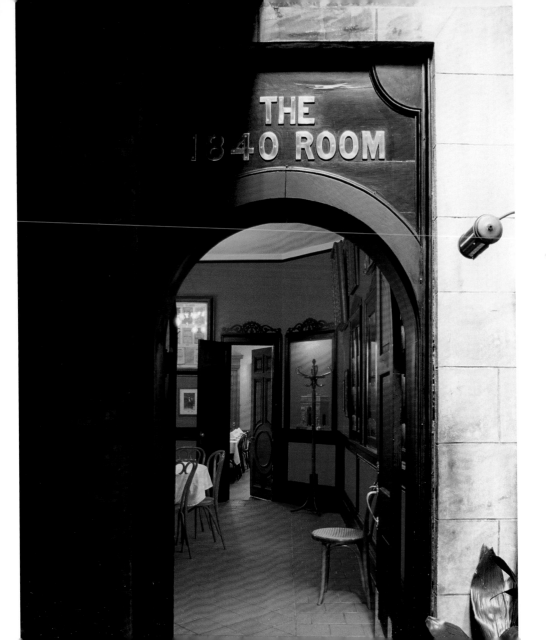

" ... America's **single** greatest contribution to **haute** cuisine. **"**

LEFT: *The 1840 Room is a replica of one of Antoine's original private dining rooms. Portraits of the Alciatore family hang on the red walls, and the collection of artifacts includes menus from the early 1880s, theatre programs containing Antoine's advertisements as far back as 1852, a Confederate sword, and one of Edison's first light bulbs.*

spanish colonial
HOUSES

AN URBAN EUROPEAN DERIVATIVE, THE

Spanish Colonial house joined the provincial-style cottage on the streets of the growing Vieux Carré, just after the great fire of 1794.

BELOW: *Called New Orleans' first skyscraper, the Pedesclaux-LeMonnier House shows strong Spanish Colonial influence with a new height attributed to both American style and advancing technology.*

> **"** ... the great fire of 1794. **"**

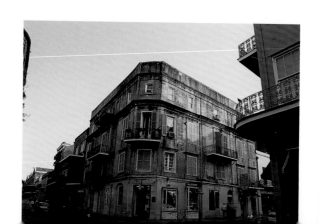

TOP LEFT: *Around 1800 architect Barthelémy Lafon built this Spanish Colonial mansion, now Waldhorn & Adler Antiques, for Vincent Rillieux, the great-grandfather of Edgar Degas.*

TOP RIGHT: *Rillieux also commissioned the building in the next block that is now Brennan's restaurant*

BOTTOM LEFT: *Dr. Joseph Montegut built this Spanish Colonial mansion on Royal Street in 1794.*

BOTTOM RIGHT: *The Chesneau House on St. Louis Street is an example of sprawling Spanish Colonial architecture from 1800.*

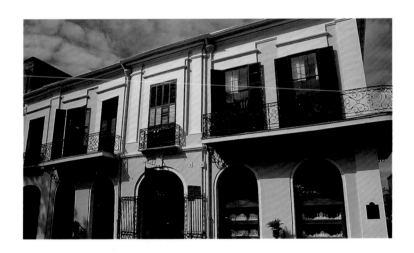

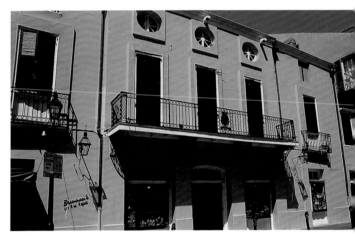

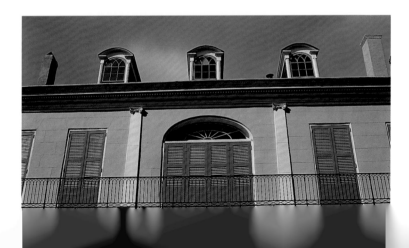

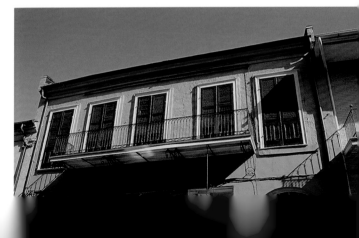

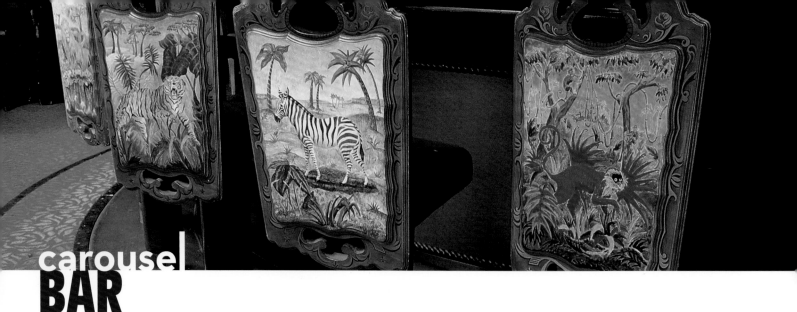

carousel
BAR

BY THE TIME YOU'VE DOWNED A MINT

julep at the Carousel Bar, a slow panorama of the whimsical interior has passed by and you're back where you started, all without leaving your seat. The historic Monteleone Hotel introduced New Orleans' first revolving bar in 1940, and the Carousel has been rotating at a rate of once every fifteen minutes ever since.

Rue Royale
Royal

" ... the whimsical interior has passed by and you're back where you started ... "

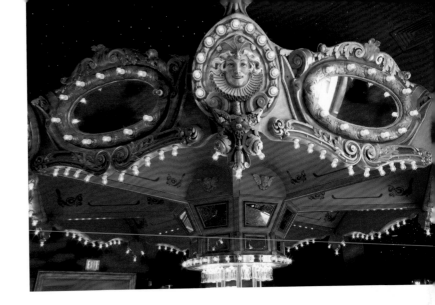

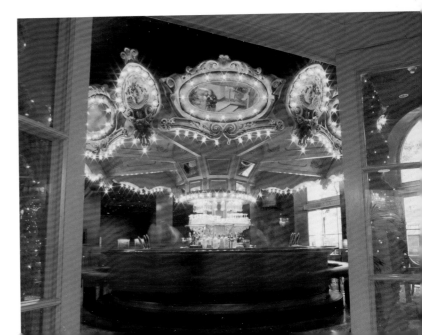

TOP RIGHT: *In 1990, Diane Montgomery designed the new renovation of the Carousel Bar using the talent of painter Pat Culler. The top portion of the bar was built by California carousel maker John Barrango.*

BOTTOM RIGHT: *The Carousel Bar used the talent of painter Pat Culler to achieve its signature appearance.*

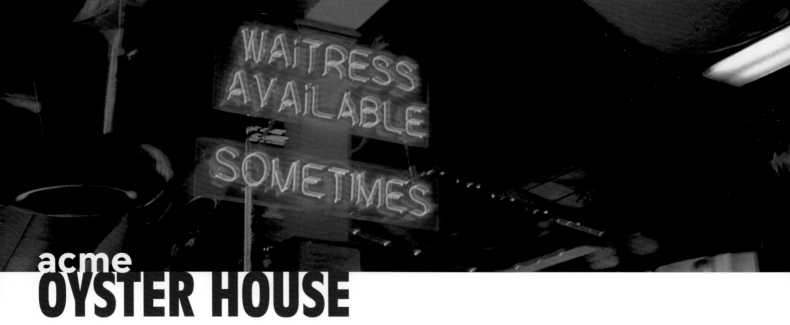

acme
OYSTER HOUSE

ACME OYSTER AND SEAFOOD HOUSE,

originally called the Acme Café, started shucking in 1910 at 117 Royal Street, next to the old Cosmopolitan Hotel. A century ago, this block was a hot spot of social and political life. Stanley Clisby Arthur's *Old New Orleans* says, "Many a Central American revolution was hatched by Spanish-speaking guests" at the Cosmopolitan's St. Regis restaurant. Across the street, at the original Sazerac Coffeehouse, eighteen bartenders served New Orleans' whiskey cocktail sensation at a 125-foot bar.

In 1924, 117 Royal Street burned down, and Acme moved around the corner to 724 Iberville, an 1814 building where the ninety-year-old oyster house keeps on shuckin'.

" . . . an 1814 building where the ninety-year-old oyster house **keeps on** shuckin'. **"**

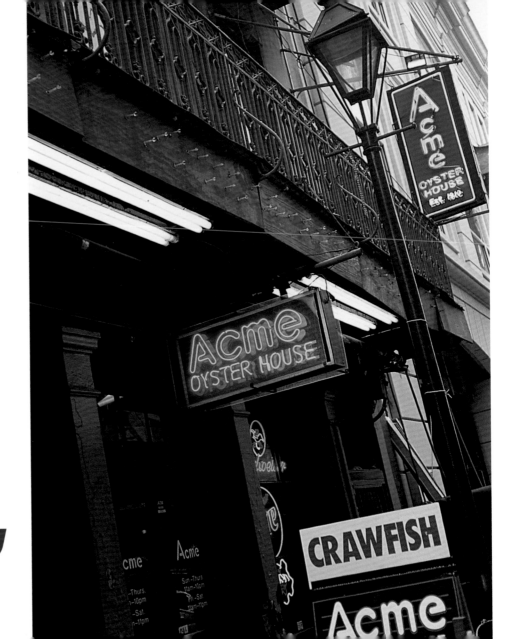

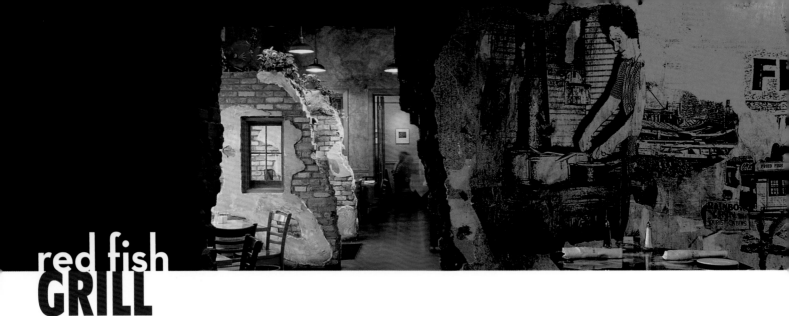

red fish GRILL

TO HOUSE THIS RESTAURANT VENTURE,

inspired by swimming things and flaming hickory, Ralph Brennan converted a corner of the old D. H. Holmes department store into an artistic, contemporary space, with sea creatures etched into the ocean-colored concrete floor and swimming in neon overhead.

When D. H. Holmes expanded and took over this section of Bourbon Street in the 1860s, the department store converted several older townhouses into its men's department. Almost a century and a half later, while building Red Fish Grill, Ralph Brennan decided to preserve the crumbling antebellum walls and incorporate them into the restaurant's design.

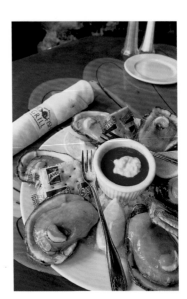

OPPOSITE, LEFT: *One of the old walls separates the bar from the dining room.*

Rue Bourbon
Bourbon

" . . . sea creatures **etched** into the **ocean-colored** concrete floor . . . **"**

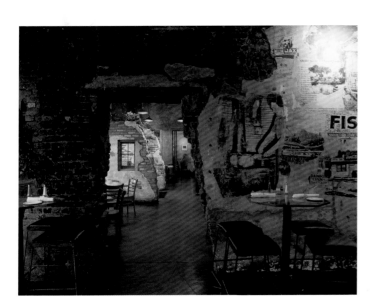

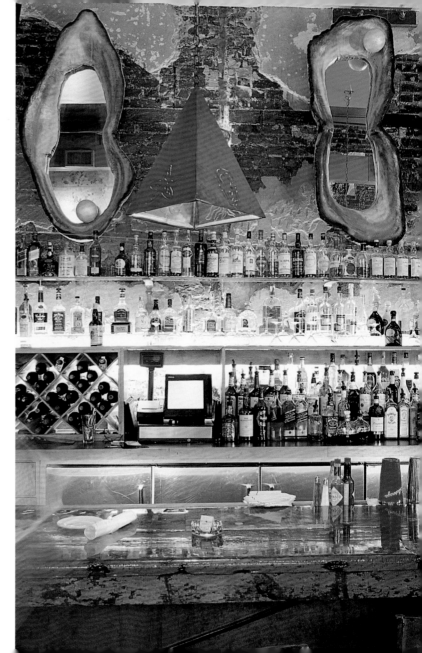

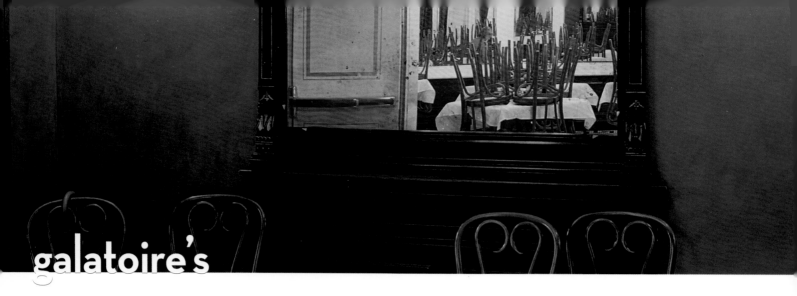

galatoire's

MANY OF THE DISHES AND MUCH OF THE

décor have remained unchanged at the New Orleans landmark since Jean Galatoire bought the Bourbon Street restaurant in 1905.

Galatoire was born in Pau, France, and came to America in 1880. For a few years, he ran a restaurant and inn in Birmingham, Alabama, before opening a saloon on Canal Street in New Orleans in 1896. In 1905 Galatoire purchased his favorite hangout, Victor's Restaurant, a popular tavern established by Victor Bero in 1830. Galatoire removed the meat hanging in Victor's front windows, decorated the dining room in mirrored Parisian style, and made his restaurant the classic institution still run by Galatoires today.

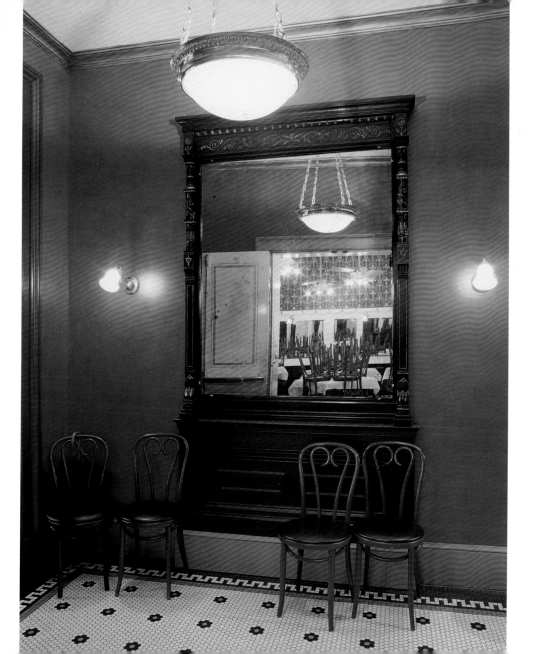

" . . . decorated the dining room in **mirrored Parisian** style . . . "

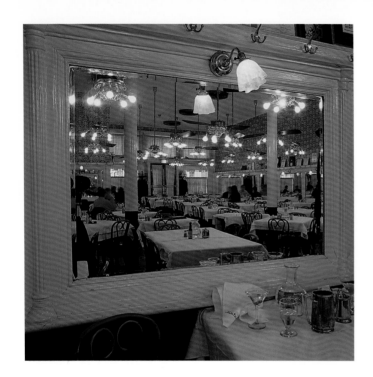

ABOVE: *Built in 1831, this Bourbon Street townhouse has been the address of America's finest Fench bistro, Galatoire's, since 1905.*

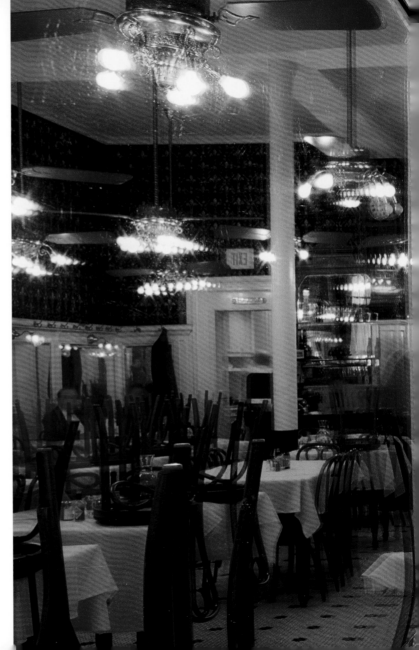

" ... classic institution ... **"**

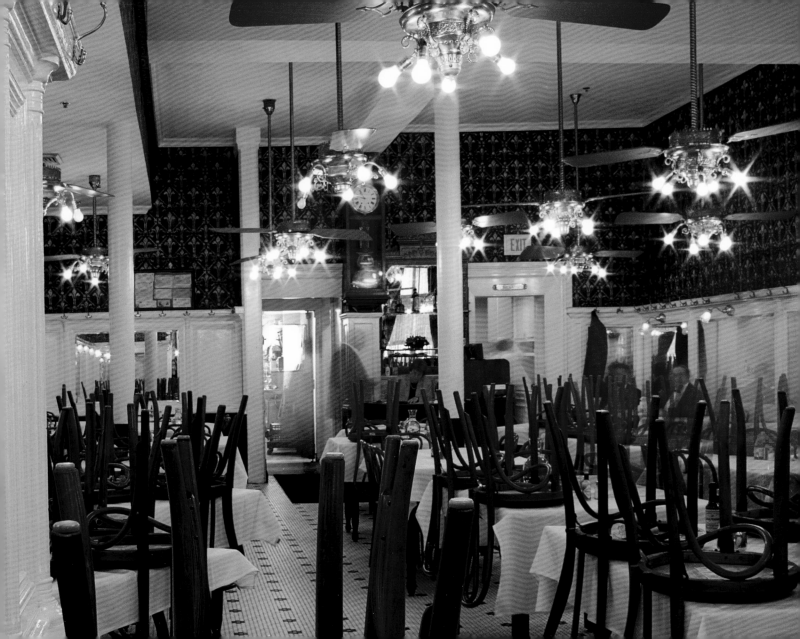

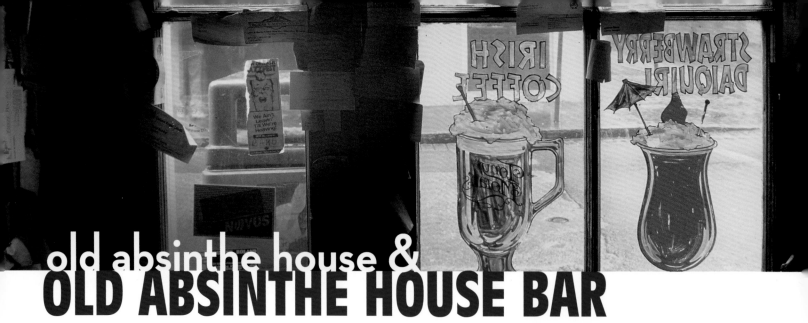

old absinthe house &
OLD ABSINTHE HOUSE BAR

A SALOON WAS FIRST CALLED THE OLD

Absinthe House in 1890, and the Absinthe Frappé dripped gaily from fountains until the Feds enforced the Volstead Act in 1920.

During Prohibition the authorities boarded up the Old Absinthe House—and this is where the confusing tale of two saloons begins. The bar and fountains were sold, or maybe stolen, from 240 Bourbon Street and moved to 400 Bourbon Street. The new location probably started out as a speakeasy and became known as The Old Absinthe House Bar. It occupies the ground floor corner of a house built circa 1838. With the repeal of Prohibition in 1933, the original Old Absinthe House reopened.

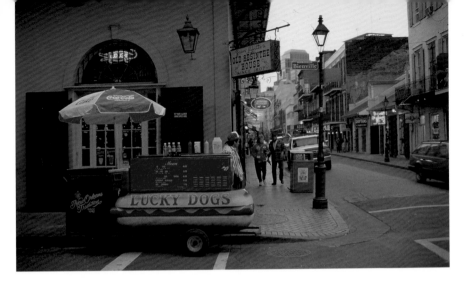

" . . . Absinthe Frappé dripped gaily from fountains until the **Feds** enforced **"** the Volstead Act . . .

 85

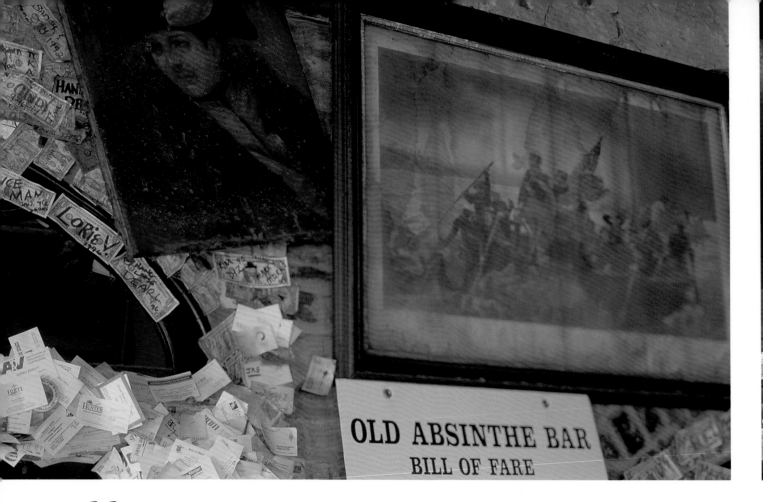

OLD ABSINTHE BAR
BILL OF FARE

" With the repeal of Prohibition in

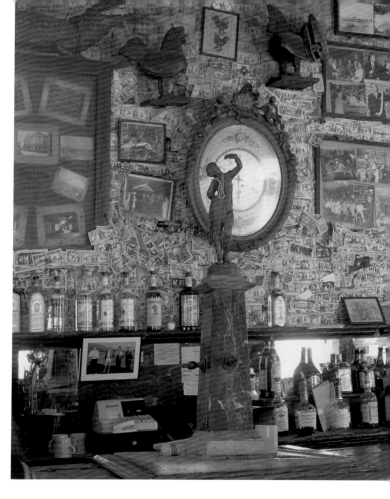

1933 … 〃

OPPOSITE AND TOP RIGHT: *A 1997 remodeling destroyed the historic interior of the Old Absinthe House Bar. Every inch of the walls, cypress beams, and ceiling inside the bar at 400 Bourbon street was covered with bills and cards, brown with age and cigarette smoke. The pinning up of tokens originated long ago at the Old Absinthe House Bar; one story tells that sailors, after being paid in the port of New Orleans, signed dollar bills and left them pinned to the wall of the bar so they might be assured a drink if they returned next time to port with no money.*

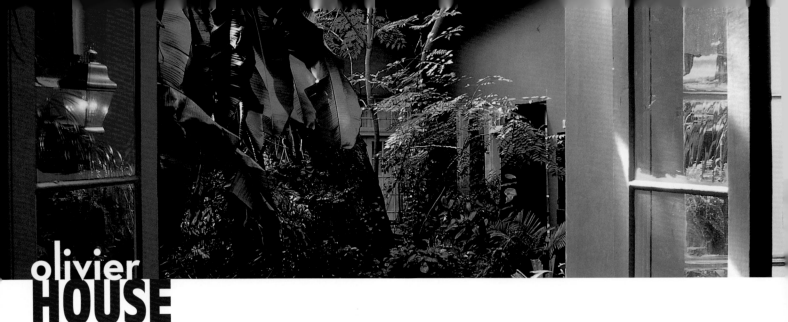

olivier
HOUSE

THE OLIVIER HOUSE HAS BEEN CALLED THE

most beautiful architecture in the Vieux Carré. Now a hotel, the Creole townhouse with a wide back stair was built in 1836. J.N.B dePouilly designed the home for Marianne Bienvenu, widow of Nicolas Godefroy Olivier, a rich plantation owner.

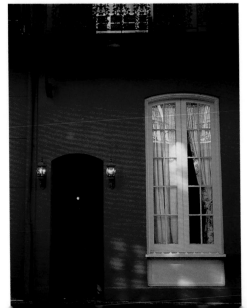

" ...built in 1836. "

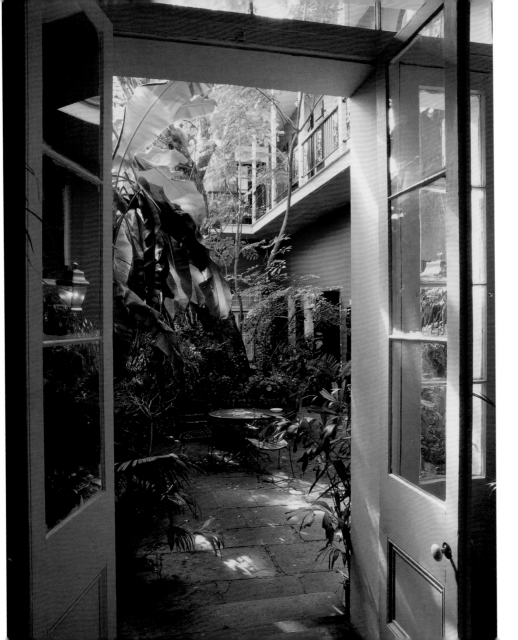
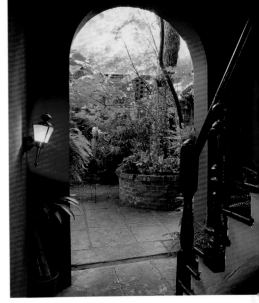

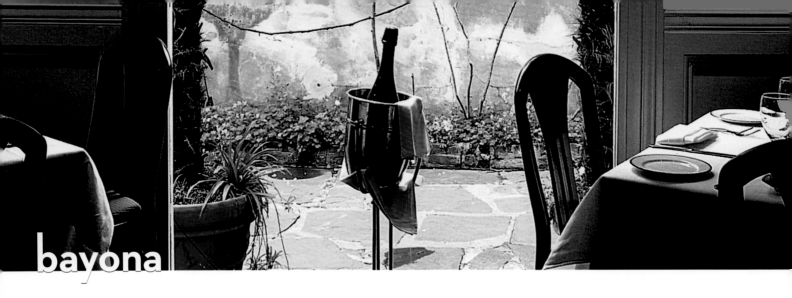

bayona

SUSAN SPICER OPENED HER FRENCH

Quarter restaurant in a 200-year-old Dauphine Street cottage. The now world-famous showplace of Chef Spicer's talent is named for a city on the coast of Spain and the old colonial street name. Under Spanish rule in the eighteenth century, Dauphine Street was Calle Bayona. Spicer lets her New Orleans roots, French instruction, and unlimited imagination simmer into a style she calls "contemporary global," including flavors from the ancient pots of India, Asia, and the Mediterranean.

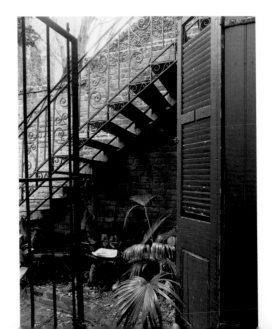

"...New Orleans roots..."

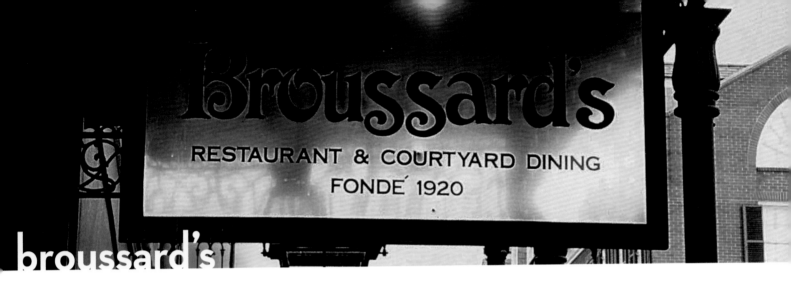

BROUSSARD'S PROPERTY BACKS UP TO THE

1831 Hermann-Grima House, and the actual building is an amalgam of several older structures. In addition to serving as the Borrello mansion, the structure includes portions of what was the Jefferson Academy, and the back dining rooms and courtyard occupy the old washroom, stables, and slave quarters of the Hermann-Grima home.

Joseph Segretto completed the first restoration of the Broussard's building in the 1970s. The Preuss family maintained the Grand Dame of the French Quarter for more than two decades. In 2013, the Ammari family took ownership and renovated the entire public area to preserve its charming character while bringing it up to modern standards. The classic courtyard is a major attraction, boasting what is believed to be the oldest wisteria vine in the French Quarter.

"... Grand Dame of the French Quarter ... **"**

 91

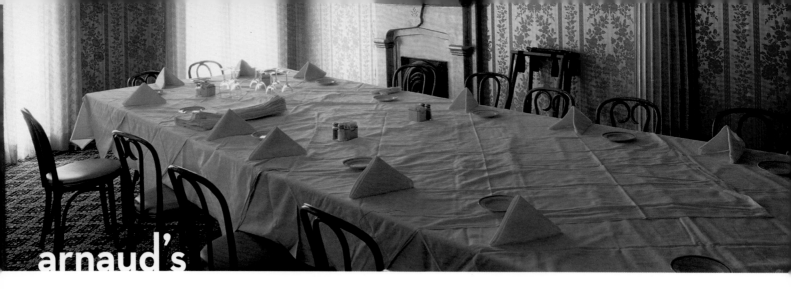

arnaud's

IN 1918 LEON BERTRAND ARNAUD

Cazenave bought an old warehouse on Bienville Street and built his famous namesake restaurant. He ruled over the lavish Creole establishment like a magnanimous royal, drank champagne every day for breakfast, and stayed out all night on Bourbon Street with friends. Somewhere along the line, his grand and elegant style earned him the nickname "Count."

When Cazenave bought the warehouse that would become Arnaud's, houses of prostitution and drug dens populated the area. But the unsavory neighbors did not hamper the success of the restaurant, and slowly, Cazenave purchased the surrounding properties. The main building dates to 1883 and connects to

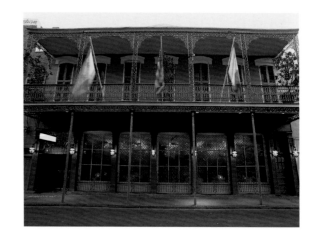

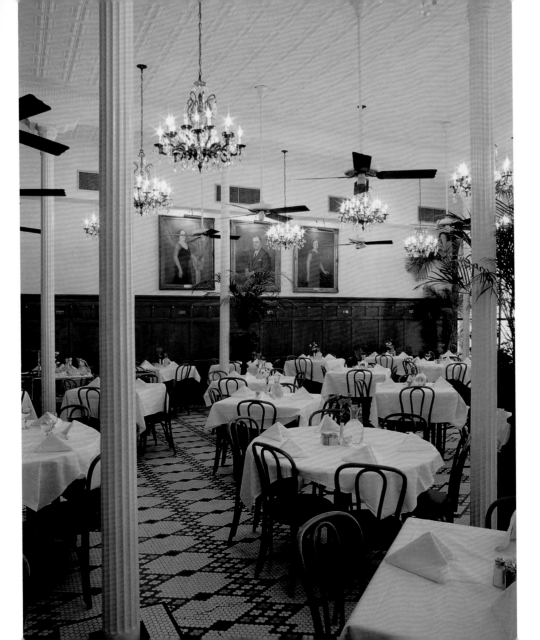

ABOVE: In Arnaud's surreal museum, mannequins display Germaine's French-made ball dresses.

LEFT: Portraits of the Count; his wife, Lady Irma; and daughter, Germaine, watch over Arnaud's main dining room, one of the grandest spaces in the French Quarter. Original chandeliers, fans, iron columns, and Italian tile floors remain in place. The new owner, Archie Casbarian, had the old tin ceiling replicated. Silver, glassware, and china patterns are those chosen by the Count himself. Buzzers, used to summon waiters in the small second floor private rooms, still work.

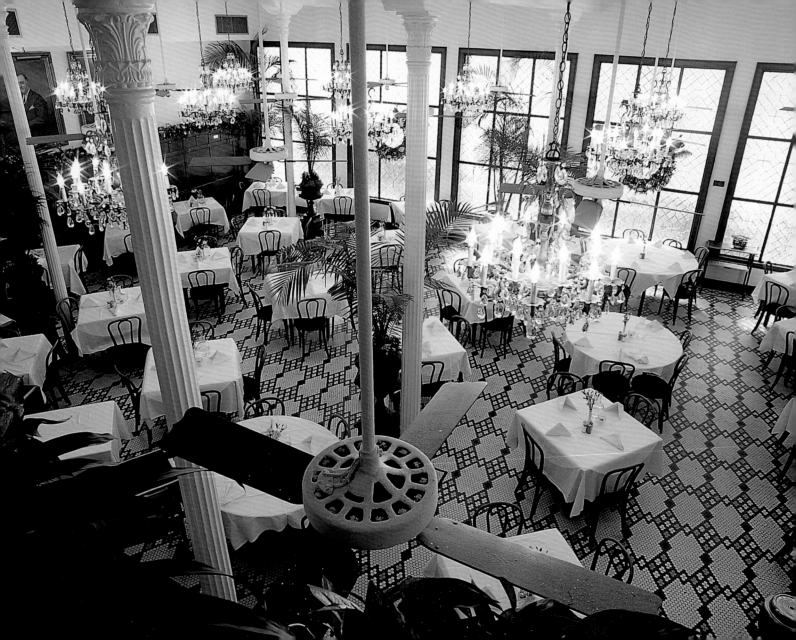

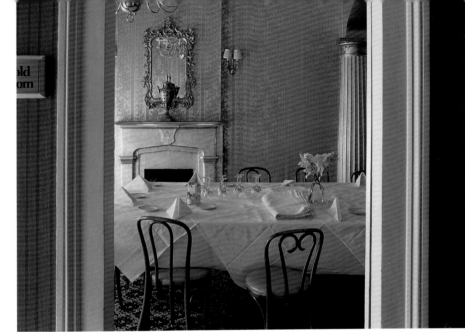

eleven other nineteenth-century structures. They say that ghosts of opium fiends chill the air in the Richelieu Bar, one of the oldest of the conjoined buildings.

" ... ghosts of opium fiends chill the air in the Richelieu Bar ... "

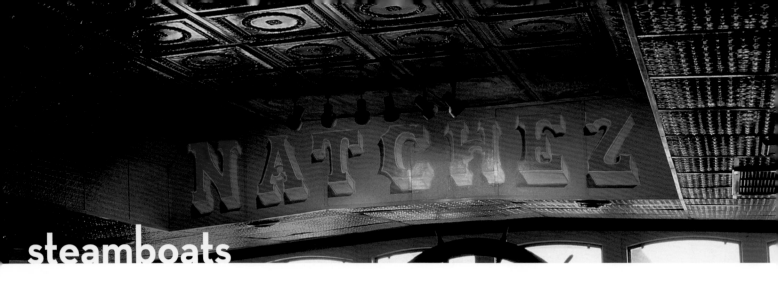

steamboats

AT ONE TIME, TRAFFIC ON THE MISSISSIPPI

River went only one way—downstream. The first Mississippi steamboat, called the *New Orleans*, changed all that. In 1812, the paddle-wheeler made a 2,000-mile trip from Pittsburgh to the Crescent City, beginning a long tradition of steam-powered trade and passenger travel.

OPPOSITE: *In 1823 the first steamboat named Natchez ran the route from New Orleans to Natchez, Mississippi. Today, the latest incarnation takes passengers out on the Mississippi twice a day to experience the river like Scarlett and Rhett, in the luxury of an authentic mid-1800s steamboat.*

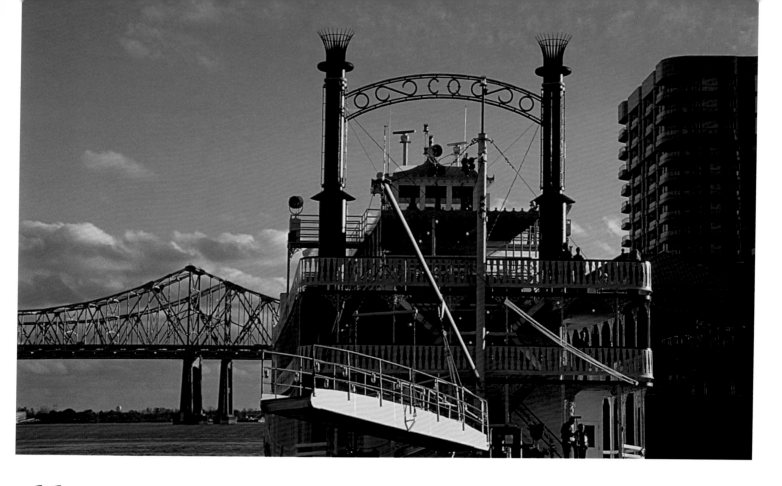

" ... a long tradition of steam-powered trade ... "

lagniappe

Many of these items can be seen throughout the French Quarter, so look around for a host of visual delights.

LOCALES

ceramic street
NAME TILES

THE CITY BEARS REMINDERS OF ITS colonial heritage through ceramic tiles of the street names in their Spanish form. They are found near the corner, a few feet above the sidewalk, on the walls of many French Quarter buildings.

"...on the **walls** of many French Quarter buildings."

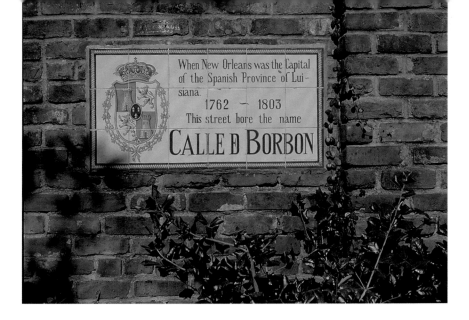

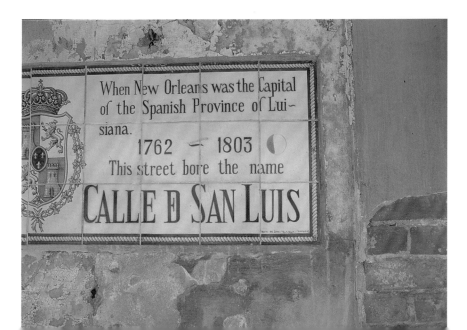

> **"**...colonial heritage...**"**

TOP LEFT: *This sign is located near Laffite's Blacksmith Shop.*

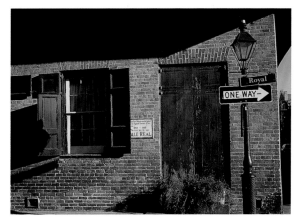

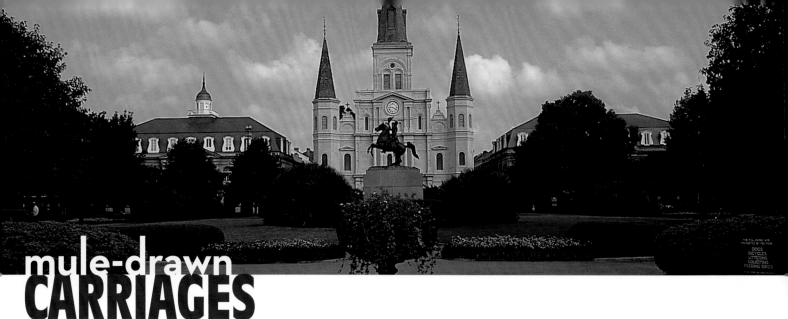

mule-drawn
CARRIAGES

HARKENING BACK TO THE TRADITIONS

of Old New Orleans, horse- and mule-drawn carriages offer pedestrians a chance to connect with the past as they enjoy the view from a comfortable seat and learn of the history and mystery of the buildings they pass. Traditionally anchored to Jackson Square, the carriages traverse the Quarter daily.

" ...a chance to connect with the past ... "

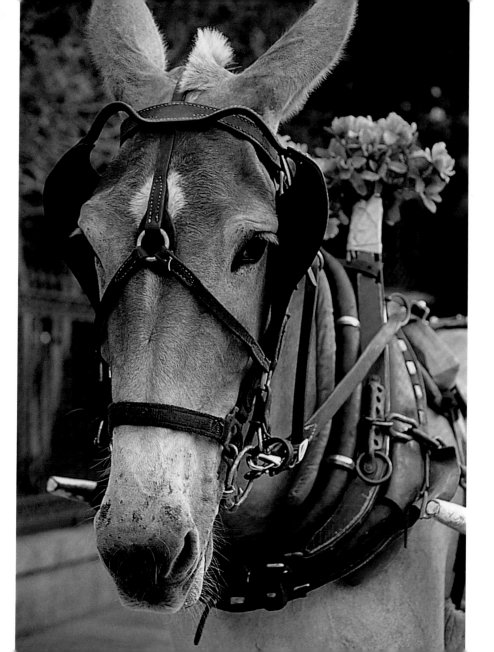

" ...learn of the **history** and **mystery** of the buildings... **"**

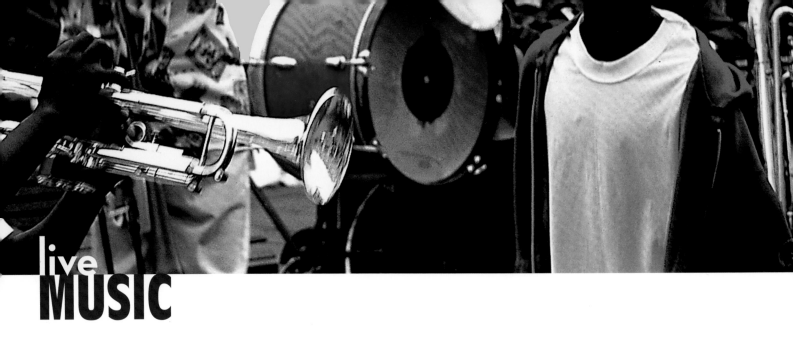

live MUSIC

LONG BEFORE YOUR EYES BEHOLD THE

source, your ears will lead you to the music from any number of performers throughout the city. Spilling out of open doors or reverberating around corners, music greets visitors day and night in the French Quarter.

The Vieux Carré changes and shifts, every day revealing some new magic in the movement of the old. There is no end to the colors and tones of the French Quarter rhapsody. And the music plays on and on.

" ... the music plays on and on. "

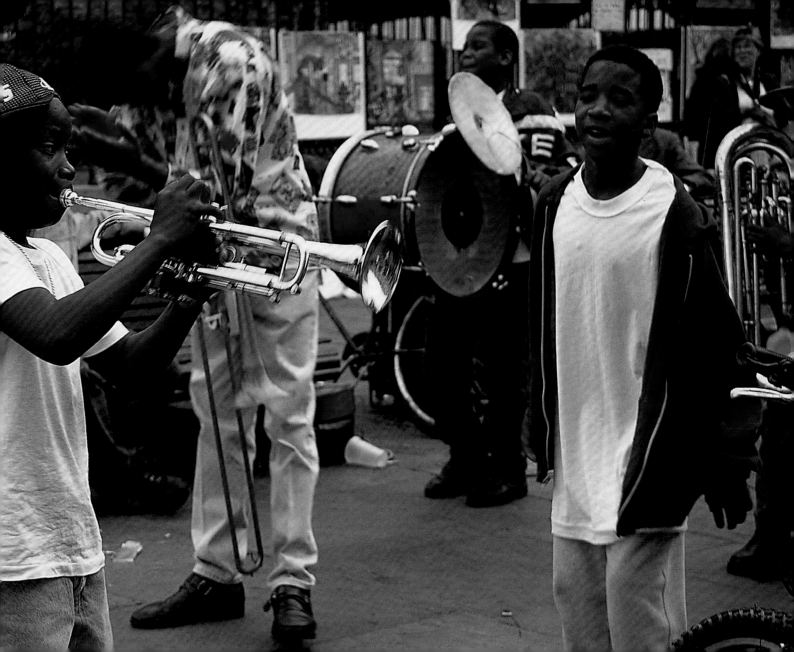

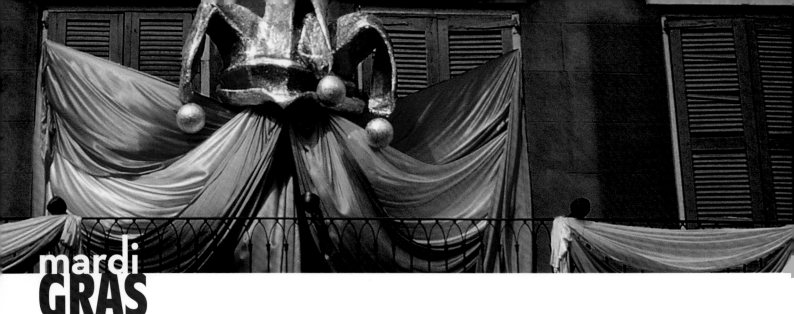

mardi GRAS

CENTURIES AGO, THE ROMAN CATHOLIC

Church adopted an ancient, pagan spring fertility ritual that it could not suppress. In the nineteenth century, the French Quarter, a Catholic culture with a pagan heart, lustfully embraced the pre-Lenten bacchanal, and every year Mardi Gras gushes into the French Quarter with a river of liquor and merriment.

On Fat Tuesday in the French Quarter, masked revelers swarm under balconies overfilled with rowdy onlookers.

Even after Carnival season, the spirit and memorabilia of Mardi Gras linger throughout the city, especially the coveted, colorful plastic beads.

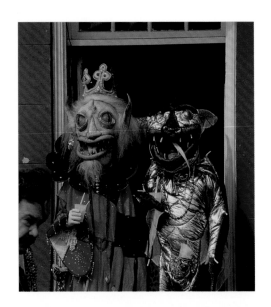

" . . . the French Quarter, a Catholic culture with a **pagan heart,** lustfully embraced the pre-Lenten bacchanal . . . **"**

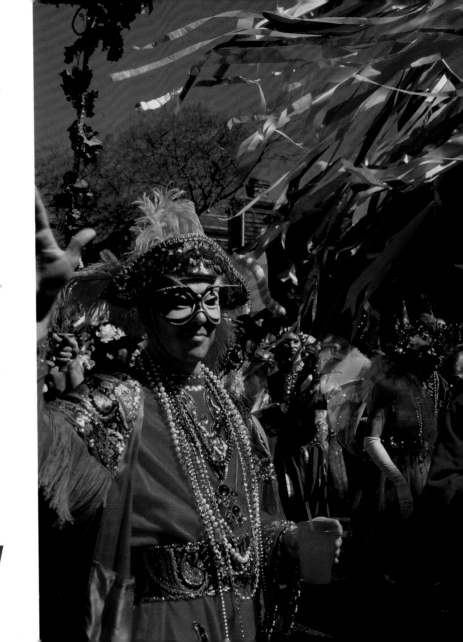

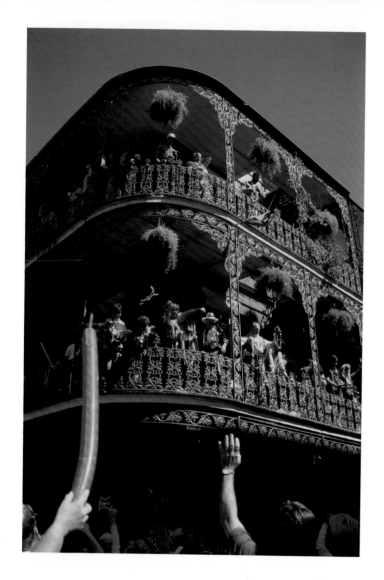

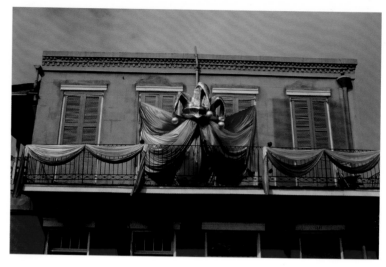

" ...masked **revelers** swarm under balconies ... **"**

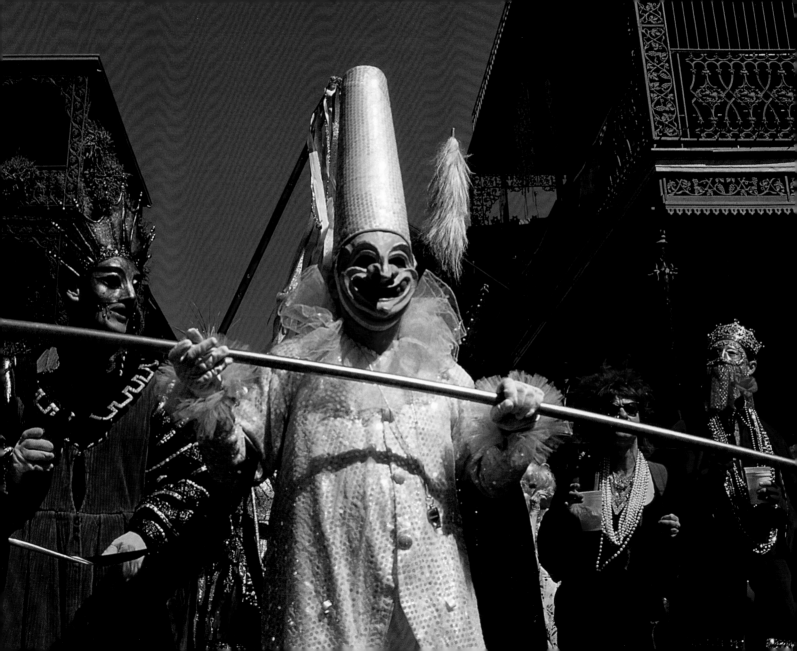